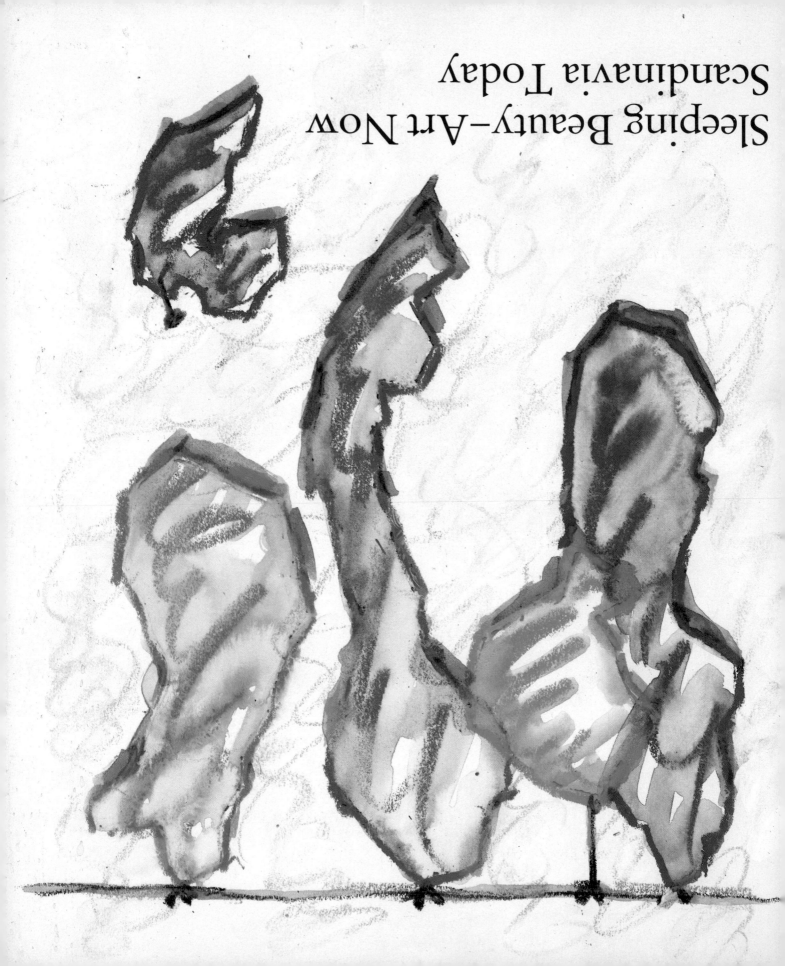

Sleeping Beauty—Art Now

The Book of Sleeping Beauty
Title given to the chief early work of author
Carl Jonas Love Almquist, born 1793 in Stockholm,
lived 1851–1865 in USA, died 1866 in Bremen.

*"Everything I do is completely original—I made
it up when I was a little kid."*
Claes Oldenburg, who made the cover for this
catalogue, *Hanging parts of Scandinavia*, American
artist, born in Stockholm in 1929, lived in Oslo
from 1933–1937 and is now living in New York.

Sleeping Beauty–Art Now
Scandinavia Today

The Solomon R. Guggenheim Museum, New York

Sleeping Beauty—Art Now, a project of SCANDINAVIA TODAY, was made possible by grants from Skandia America Group, A. Johnson & Co., Inc., Alfa-Laval Inc., Atlas Copco North America Inc., The SKF Group, American Scandinavian Banking Corporation, and The G. Unger Vetlesen Foundation.

SCANDINAVIA TODAY, an American celebration of contemporary Scandinavian culture, is sponsored and administered by The American-Scandinavian Foundation, and made possible by support from Volvo, Atlantic Richfield Company, the National Endowment for the Humanities, and the National Endowment for the Arts.

SCANDINAVIA TODAY is organized with the cooperation of the Governments of Denmark, Finland, Iceland, Norway, and Sweden through the Secretariat for Nordic Cultural Cooperation and with the aid of a grant from the Nordic Council of Ministers.

SAS, Finnair and Icelandair are the official carriers for SCANDINAVIA TODAY.

Published by The Solomon R. Guggenheim Foundation, New York, 1982

ISBN: 0-89207-036-6

Library of Congress Card Catalog Number: 82-060793

Printed and bound in Sweden

Exhibition 82/6

4000 copies of this catalogue have been designed by Lennart Landin and printed and typeset by Bohusläningens Boktryckeri AB, Uddevalla, Sweden

Contents

Sponsor's Statement

Artists of the mid-twentieth century, living as they do in a period of widely ranging cultural influences and widely fluctuating socio-economic patterns, have turned to new techniques and materials in their search for artistic identity. Scandinavian artists have responded to societal changes in an intensely individualistic way that accepts the positive values of this global input without rejecting the rich history and folklore of their own countries.

The freedom with which they use the great flood of available new information while continuing to live within their tradition seems to us to be particularly appropriate and valuable today.

It is therefore a great pleasure for us to be able to contribute to the realization of the *Sleeping Beauty – Art Now* exhibition, which focuses on the work of a number of young Scandinavian artists, each of whom in a unique and personal style has told us something new about who we are and what possibilities are open to us.

Pehr G. Gyllenhammar
Managing Director
Volvo Group of Companies

Robert O. Anderson
Chairman
Atlantic Richfield Company

Lenders to the exhibition

Bo Alveryd, Kävlinge, Sweden
Bård Breivik, Stockholm
Lars Englund, Stockholm
Hreinn Fridfinnsson, Amsterdam
Sigurdur Gudmundsson, Amsterdam
Sirkka Knuuttila, Helsinki
Olle Kåks, Stockholm
Launo Laakkonen, Helsinki
Kirsti Lyytikäinen, Helsinki
Olli Lyytikäinen, Helsinki
Bjørn Nørgaard, Copenhagen
Paul Osipow, Järvenpää, Finland
Arvid Pettersen, Oslo
Sebastian Savander, Helsinki
Ulla and Stefan Sjöström, Stockholm
Milla Trägårdh, Stockholm
Stuart Wrede, Connecticut

Amos Anderson Art Museum, Helsinki
The Art Museum of the Ateneum, Helsinki
Det Faste Galleri, Trondheim, Norway
Helsingin Kaupungin Taidemuseo, Helsinki
Moderna Museet, Stockholm
Musée National d'Art Moderne, Centre Georges Pompidou, Paris
Rijksmuseum Kröller-Müller, Otterlo, The Netherlands
Stedelijk Museum, Amsterdam

City of Amsterdam
Den norske Creditbank, Oslo
State-Owned Art Collections Department, The Netherlands
Svenska Handelsbanken, Stockholm

Galerie Fred Jahn, Munich
Galleri K., Oslo
Galerie Hans Neuendorf, Hamburg
Galerie Michael Werner, Cologne

Acknowledgments

The following expressions of gratitude are made in my own behalf and in that of my co-commissioner Pontus Hultén.

Our grateful acknowledgment is due first to Björn Springfeldt, Senior Curator of the Moderna Museet, Stockholm, who acted as Nordic coordinator of the exhibition and also edited the catalogue.

It would not have been possible to arrange this exhibition, *Sleeping Beauty—Art Now*, without the generosity extended by a number of artists and museum representatives both in Scandinavia and in other countries. To all these we offer our deep appreciation.

We would like to acknowledge the fact that the Nordic Council of Ministers provided the funding for the preparation of the exhibition. The work of various individuals and institutions in Denmark, Finland, Iceland, Norway, Sweden, and the United States was coordinated by the Secretariat for Nordic Cultural Cooperation with efficiency and diplomacy. In an enterprise of this magnitude, bringing together artists and cultural institutions in six countries, there is always a risk that the artistic content of a project will be diminished.

However, under the guidance of Carl Tomas Edam, Secretary General of SCANDINAVIA TODAY at the Secretariat for Nordic Cultural Cooperation, it has been possible to solve all major problems in this regard and consequently foster the interest of the artists and their works. To him and his staff of Bente Noyons and Birgitta Schreiber we owe a great debt.

We are grateful to Mrs. Birgitta Lönnell, Press Attaché, Swedish Information Service, New York, for all her help. Øystein Hjort accepted the difficult task of outlining the artist's social and economical situation in Scandinavia for which we owe him great debt. Åke Larsson undertook the coordination of all transportations and solved all problems involved in a way we are most grateful for.

Sincere thanks are extended to Louise Averill Svendsen, Senior Curator of the Guggenheim Museum, for her central contribution as Coordinator of the exhibitions Asger Jorn, Öyvind Fahlström and *Sleeping Beauty—Art Now* in the presentation of Scandinavia Today at the Guggenheim.

The efforts of virtually every departement of the Guggenheim Museum were involved in this project, and the dedication and skill of staff members are therefore gratefully recognized. Our appreciation is also extended to the lenders, both private individuals and public institutions, whose willingness to part with their possessions is greatly appreciated. Except for those who wish to remain anonymous, lenders are cited on the preceding page.

Our hearty thanks go to Lennart Landin in Uddevalla, Sweden, for masterly designing the catalogue. Our gratitude also goes to Claes Oldenburg for his willingness in rendering Scandinavia for the cover of this publication.

The organization of SCANDINAVIA TODAY on the American side could not have been accomplished without the administrative framework and willing support of The American-Scandinavian Foundation. Individual as well as collective encouragement for the

program came from museum directors, curators, administrators and technical support staff who lent their expertise, experience and enthusiasm.

We would be at fault, however, if particular recognition were not given to those responsible for the entire SCANDINAVIA TODAY program: to Patricia McFate, President of The American-Scandinavian Foundation, who secured funding and set program policy in the United States; to Brooke Lappin, who guided and directed the SCANDINAVIA TODAY program; to Bruce Kellerhouse, who coordinated all of the program activities; and to Albina De Meio, who undertook liaison work between the Nordic side and all participating American museums. Without the support and talents of these highly skilled professionals, the SCANDINAVIA TODAY program could not have evolved.

The exhibition *Sleeping Beauty—Art Now* will, after it's showing in New York, go to Philadelphia and to Los Angeles. We want to extend our gratitude to Mr. Ronald L. Barber, Director of Port of History Museum, Penn's Landing, Philadelphia and to Mrs. Josine Ianco-Starrels, Director of the Municipal Art Gallery in Los Angeles. We thank them for their interest, help and cooperation.

Thomas M. Messer
Director
The Solomon R. Guggenheim Foundation

Little History & Explanation

Pontus Hultén

"All national art is bad, all good art is national."

Christian Krohg (1852–1925)
Norwegian painter

"Our geography, we cannot change."

J. K. Paasikivi (1870–1956)
Finnish statesman

"Only Sweden has Swedish gooseberries."

Carl Jonas Love Almqvist (1793–1866)
Swedish author

"I have loved the Danish language as Adam loved Eve. There was no other woman."

Sören Kierkegaard (1813–1855)
Danish philosopher

"'Am I to go in with this soup?' say I. 'Yes, for Heaven's sake,'" replies the cook, who is hard of hearing, and one of the greatest sinners of our age; she has hung a colored picture of the Savior above the steel sink.

Halldór Kiljan Laxness (1902–)
Icelandic author

The reason why the Scandinavian countries—Denmark, Finland, Iceland, Norway and Sweden—are grouped together is that they are all situated in one corner of Europe, and they are all small in terms of population. Their modern history is, however, not parallel at all. And one can question if their contemporary culture is very coherent. Four countries speak more or less similar languages of Germanic root, but the Finns speak a totally different language which is not Indo-European in origin.

With some effort, one can, however, establish a list of common elements and factors in their respective cultures of today, most of them related to the light, the climate, in some cases a common ethnic origin and older cultural links, going more or less far back into history. On the other hand, although Danes and Swedes have not been separated into two distinct countries for more than about a thousand years, and Swedes and Norwegians less than one hundred years, there is in many cases no difficulty in distinguishing a Dane, an Icelander, a Norwegian and a Swede by facial expressions, movement patterns, and their general behavior before they have opened their mouths. The Finns often look very different from, for example, the Swedes, although they can be as blonde, even blonder than the Scandinavians of northern European, Germanic, Indo-European origin.

For somebody looking at the Scandinavians from the outside, it is, however, probably easier to see how they are alike. For us, it is more interesting to contemplate how we are

different. We come from very different situations in terms of modern history. In the middle of the nineteenth century, the Danes, a rich and rather well established and even, in part, rather bourgeois nation was trying to sort out its complicated relations with the Germans, their southern neighbors, who for a long time had had a strong economic and cultural influence. Norway, which had been a poor part of Denmark, was now a kingdom, but sharing its king with Sweden. It started to develop its national characteristics and very quickly produced a magnificent literature with Ibsen, Bjørnsson and later, at the end of the century, Hamsun, and great painters like Krohg and Munch. Iceland was one of the poorest parts of Europe, economically and even culturally plundered by the Danes and Norwegians. Sweden was slowly emerging from a long series of military and political catastrophies in the nineteenth century. It was a rather poor country at this time, culturally more influenced by France and England than by Germany. It had not developed a bourgeois culture of the central European type and never would. Finland, a part of Sweden for at least a thousand years, had been lost to Russia in the Napoleonic wars. Finland had a very special and somewhat privileged role amongst the Russian provinces. The Finns would be important in the background of the extraordinary explosion of cultural vitality that took place in St. Petersburg at the turn of the century.

In the beginning of this century, a number of changes occurred that led to the establishment of the present national situation. Norway separated itself from Sweden and became an independent kingdom. Finland, as a result of the February and October revolutions in 1917, became first a kingdom and then a republic, after a civil war that would mark its future for a long time. Only Iceland remained a dependent part of Denmark, and became a republic at the end of the Second World War. Denmark, Norway and Sweden remained neutral in the First World War, and this contributed to the isolation that results from the geographical situation (it became a dead end part of Europe when the Soviets more or less closed their border after the end of the civil war following the October revolution).

The time between the wars was a relatively dull period culturally speaking. The Second World War reserves a fate that would for a long time separate the Scandinavian countries. Finland was attacked by the Soviet Union in two succeeding wars of great violence. It managed to survive (whereas, for example, the Baltic states were absorbed by the Soviet Union). Finland lost one third of its territory, and 85,000 dead. Denmark and Norway were occupied by the Nazis and developed important resistance movements, but were liberated only late in the war. Iceland was occupied first by the British and from 1941 it was governed by the U.S., who after "negotiation" took over the role of the British. Only Sweden remained neutral, perhaps mainly due to its geographical situation. This lead to a greater isolation for Sweden that could be felt for a long time, perhaps even today, more than a generation after the end of the war.

The present cultural conditions have developed from the situation between the two World Wars. A very quick and, of course, extremely sketchy survey of that situation gives the following picture: In Iceland, one artist, Johannes Kjarval, 1885–1972, dominated the local scene in terms of creative action, which, generally speaking, was very quiet. The main writer, Halldór Laxness, had left Iceland to live in France and Italy. In Norway, a group of important artists, most of whom had lived in Paris for some years, came back to Oslo in the thirties, where they established themselves in the tradition of the artist-hero, modelling themselves after such examples as Munch or rather Vigeland (and the great Mexicans such as Rivera, Orozco and Siqueiros). Their theories about society and art were slightly socialist or Marxist (as in Mexico) in a typical thirties way, and their aspiration was to cover the maximum number of walls in public buildings with their art. They dominated the

Norwegian art scene totally and managed to maintain their supremacy well into the fifties and early sixties. It could perhaps be said that Norwegian art is still suffering from the fact that one generation thus was allowed to sit at the fleshpots, more or less undisturbed, for such a long time.

In Denmark the situation was totally different. The contact with Paris and the Bauhaus was more lively. A group of very young artists, some of whom would become very important after the war, had made a breakthrough and already established themselves before 1939, when some of them were only about twenty years old (Linien). Their idols were artists like Kandinsky and Klee, as well as Mondrian and the great Russians. Their vital avant-garde spirit survived the war years—some of these artists played a role in the Danish resistance movement—and immediately after 1945 they renewed their international contacts, and two of the most important—Robert Jacobsen and Richard Mortensen—moved to Paris, where they stayed for many years. Parallel to this movement that was resolutely oriented towards abstract art and the avant-garde, at least in its second phase, was the COBRA group (COBRA—Copenhagen, Brussells, Amsterdam) whose prime mover was the Danish artist Asger Jorn. Jorn would also move to Paris but would spend long periods of his time in Denmark and Sweden. A rich and complicated national—international situation resulted, its richness still felt today, although a certain mannerism, typical for some Scandinavian cultural environments, has been creeping in.

In Sweden, the thirties was a rather bleak period. The decade had started with an artistic catastrophe. For the World's Fair held in Stockholm in 1930, which became the great introduction to "functionalist" architecture in the Nordic countries, the Swedish artist Otto G. Carlsund had brought together a great exhibition of works by Mondrian, Vantongerloo, Léger, Hélion, etc. It was received by the press and public in the most fearful manner. Carlsund had a breakdown, the works were dispersed, and some have not yet, even today, been recovered. From the beginning of the decade an artist cooperative called "Color and Form," representing a romantic, sometimes expressionistic naturalism of a rather nationalistic (or provincial) kind, also more or less totally dominated the market. After the immediate postwar period, some younger artists started to show rather timid non-figurative work based on formal ideas coming from the Bauhaus vocabulary and inspired by the play of positive—negative forms in the *Guernica* structure. It would take until the early sixties for Sweden to recover from the isolation it had been forced into by the war and the "neutrality."

In Finland, again, the picture was different. In the thirties, a certain landscape tradition of quality, but difficult to understand or appreciate when seen from the outside, prevailed. After the wars it took, for obvious reasons, some time for Finnish culture to reestablish itself. As soon as the young artists could travel, many of them turned towards Italy, rather than to France, as is the Finnish tradition.

The present situation in the artistic life of the Scandinavian countries today and something about the artists showing works in this exhibition, and why they were asked to participate.

There is no overall pattern common to the situation of the pictorial arts in the five Scandinavian countries today. As has been said, the historical background is very diversified, and the flood and tide in the art life does not run with the same moon. However, when the proposition of the present exhibition was discussed, it seemed necessary to look

upon the art produced in Scandinavia as from one country, and the works to be shown would have to be chosen so that the whole would give a total picture of a very diversified situation. It would, at the same time, have to make a coherent and beautiful exhibition, true to the richness and complexity of the art life in Scandinavia. The magnitude of the difficulties in putting such an exhibition together can be appreciated by those who have tried something similar. (The effect on friendship and good relations is disastrous, it seems that in the end, everybody hates you, for one reason or another.) It is important to know that the selection (of two artists from each of the five countries) is *not* the result of an evaluation of the art in each country but is based on concern for the public's experience of the exhibition as a whole and on the general image this whole can give of art in Scandinavia today. It is obvious that the result will not satisfy anybody.

The art in the different countries will be discussed in alphabetical order as follows:

In the kingdom of Denmark, the present situation in the field of art is quite lively. It seemed that two well-established artists, now in their forties, are best suited for this particular exhibition: Per Kirkeby and Bjørn Nørgaard. Both have already gone through a long series of different experiences, which seems rather typical for the younger Scandinavian artists. Kirkeby started as a scientist, in geology, lived in Greenland for some time, but has been active mainly as an artist for a long time. His art has changed considerably during this period. His art has, however, remained related to his experience as a geologist, but in a rather secret way. Generally speaking, his paintings take a long time to reveal their content. They belong to a kind of expressionism (often related to Germany) that is now very much in fashion. Kirkeby has been doing this kind of painting for a very long time—actually, it is the kind of painting he did at the beginning of his career.

Kirkeby's paintings have a background in a long tradition of lyrical-romantic landscape painting in Denmark, to which Emil Nolde also belonged. (Nolde was born at the Danish-German border.) On this occasion, it could be said that it is axiomatic that the less known art from peripheral countries always imitates the better known art from the center. It is of no importance if dates and documents presented prove the contrary. Even the attempt to prove the contrary is regarded as regional busybodiness or, in the best of cases, as touching wishful thinking.

Bjørn Nørgaard's origin as an artist belongs in the Nordic-German-Fluxus-happenings fetishist trend of the sixties. It should be mentioned that both Kirkeby and Nørgaard as very young artists contributed to the artistic energy that brought Joseph Beuys to Copenhagen and that the resulting collaboration was very close and of vital importance for all parties involved. Nørgaard has made some very striking and beautiful happenings, his art is strongly related to performance and his sculptures are theatrical in the best sense of the word, meaning they contain important tension between formal structure and their compressed content.

In Finland, art is traditionally very diversified, moving in many parallel directions. The artists are quite independent and may therefore be oriented towards various international sources, maintaining contacts with the art of The United States, France, Italy, etc. at once. Two somewhat but not altogether contrasting attitudes can be seen in Finland even more clearly than in the other countries: the fascination with the autochthonous and the craving to participate in the art-life of the world, to break their isolation. The two Finns in the exhibition clearly represent these non-conflicting alternative attitudes. Olli Lyytikäinen, a most original artist, sometimes, it seems, reaches back into the magic world of the very little-known Finnish symbolist period at the beginning of the century, the years of the older Saarinen, Hugo Simberg, Axel Gallen-Kallela and the young Sibelius, years when the

great master Vroubel was teaching at the Academy of the neighboring St. Petersburg. Many of Lyytikäinen's works evoke the mysteriously evasive, bittersweet and deeper tragic character of the Finnish landscape as reflected and imprinted in the hearts of its inhabitants. The inhabitants answer to the impact of their landscape in a fierce but deeply hidden humor.

Paul Osipow's paintings are directly sensual; they declare the beauty of color in a most straightforward way. Whereas they use a reference system that is easily recognizable, their presence is their own and very distinct. They are far from naive, or rather they have the naivité of a long evolution, well-resolved and clarified into evidence.

Leading Icelandic artists have often chosen to live in the center of Europe (at least for part of the time). Some have become so integrated in the art life of other cities that they are not always recognized as Icelandic, as is the case with the painter Erro, now living in Paris and Bangkok. An extremely creative group of conceptual Icelandic artists, some of whom are relatives, have now lived in Amsterdam for several years. Their art is certainly quite international in some of its aspects, but the precision, the sparseness of means of expression and the drastic humor of the ancestors is often present.

Using somewhat similar means of expression (often photography) the two Icelandic artists are quite different in their attitudes and the content of their work is widely divergent. Hreinn Fridfinnsson's works are often concerned with time and the essence of time. It is a visual poetry; a situation is created to enhance a mystery. There is never any explaining, never a going back. He has said that he is "painting with nature."

Gudmundsson uses the photo image as a vehicle for a giddy departure into a land of weightless, timeless and hilarious adventures where the humorous statement occurs only at the beginning of the trip. The visual beauty of the photo is, so to speak, the ticket. Gudmundsson has said: "I work with an idea like a sculptor with stone."

As has been mentioned, Norway was dominated by the art of the thirties well into the fifties, remaining in, even boasting about, an independent national situation, uninfluenced by "international," "cosmopolitical" art. In recent years, some younger artists have freed themselves from the combined domination of older generations and tyrannical corporatistic artists' unions (which are strongly present in all the Scandinavian countries). A new situation is developing, as in many other fields of contemporary culture. (Norwegian popular music is at its peak and contributing strongly to the international scene.) The two Norwegian artists in the exhibition represent widely different aspects of the present Scandinavian situation. Breivik's sculpture combines elements from the tradition of conceptual form, such as, for example, Brancusi's highly simplified heads, elements from folk art, perfection in utilitarian objects, and even the mysterious perversion of the handmade object that looks like a machine element. Breivik's sculptures often appear in series where the different sculptures develop and support each other in an almost cinematographic behavior, and in that way achieve a theatrical dimension.

Pettersen pursues in his painting the Norwegian fascination with the heritage of Munch and Krohg and the painters of the thirties, but he does it in a overheated, love-hate atmosphere where he only sometimes manages to get some distance and put his tongue in his cheek. He is attacking what he calls "the Norwegian variation of French late Impressionism" with an emotional engagement and an intellectual frenzy that contains a lot of irony. His version of "the return to painting" of the last years is proceeding on a tangential course and he is sailing in hard wind.

Swedish art life today is slowly getting out of the stalemate and the desert of the iconoclastic discussions, and the puritanism that appeared in the aftermath of 1968, when

cheap moralism and political activism for some time poisoned the country. The critical considerations of the early sixties had turned into a boy-scoutish tutelage for "the masses," if not into crutches for fools. The present situation is quite rich and diversified. The two Swedish artists in this exhibition—Lars Englund and Olle Kåks—have been present and showing their works for a long time. Englund has for many years been dealing with a purified space description and interpretation starting with artificial form, but has in the last decade come closer to nature's ways of building. This inspiration comes in part also from science, in, for example, his "mapping" of topological properties. He also runs parallell research in architecture and sound.

Olle Kåks showed early work at an important exhibition at the beginning of the evolution of conceptual art *Op losse schroven* at the Stedelijk Museum in Amsterdam in 1969. In the same way as some of the Finnish artists, he is now very close to an interpretation of nature in a new and personal kind of mood, not clearly representational but rather conceptual and highly subjective, related to the northern Swedish folk culture and landscape from which he comes. He has always been aware of the limiting tyranny of style and been able to stay free to apply his extensive knowledge of art history, paraphrasing, joking, borrowing, fooling around

Scandinavia: a kind of northern Balkan; little-known, neglected, misunderstood, often simplified in modern journalistic presentations into the silly, suffering since 1918 from its dead-end geographical situation that has come as a result of the Soviet Union's reluctance to open its borders or rather, its will for isolation. A wonderful part of the world; rich, modest, mysterious, difficult, partly untouched by modern international culture, still maintaining its own cultures, thousands of years old. Full of lakes, forests, lonely islands all of polished granite, winds, silence, darkness of the winters, the white nights of the summers, far between the farms, unpretentious, timid. A demonstration of the possible.

Making art. Making a living
The artist's role in Scandinavia

Øystein Hjort

The Danish government recently said no to Nordsat, a Nordic TV satellite. The project was supposed to strengthen cultural unity in the Nordic countries – or Scandinavia, as they are collectively best known in English – by promoting interest in and knowledge of one another's countries, and by making it easier to understand one another's languages. This is only one of many examples of how difficult it is to make cultural cooperation work in Scandinavia. There are things we can agree on, but at least as many which we cannot reduce to their Scandinavian common denominators.

Cultural cooperation, which is extensive, as we shouldn't forget, has naturally emerged from the recognition that the Nordic countries together take up a corner of Europe which shares certain special conditions, a common cultural heritage.

But it can be difficult to see a common heritage. Differences among the countries are marked. It stands to reason that Finland occupies a cultural and geographical position which makes a national cultural identity necessary. And it is equally obvious that Denmark has become somewhat estranged from the rest of Scandinavia as far as special interests and potentials go, since it joined the European Communities in 1972.

Denmark's Minister of Cultural Affairs recently noted that because of this, and due to its geographical position, Denmark must be seen as "a border area between Scandinavia and the rest of Europe." Denmark is thus a cultural buffer state which has opened its borders to Common Market culture, but at the same time must defend its Danish cultural identity in as much as it is also part of the Scandinavian entity.

But what is a national cultural identity today, when the western world is on its way toward a "monoculture," with an increasingly small difference between center and periphery, among other things because of what one writer calls "the collapse of the time dimension" when it comes to the mediation of trends and ideas?[1] Outside observers raise this question again and again. It was a reasonable point of departure for J. Boulton Smith, when he attempted to isolate the special features of modern Finnish painting in what is now unfortunately an outdated introduction to the subject. ". . . To what extent has modern Finnish painting an individual cultural identity? Have the best artists in this study owed much to a particularly Finnish artistic tradition, or have they simply been painters of exceptional individual talent who happened to be born in Finland?"[2] J. Boulton Smith opts for a strong Finnish character.

The question he poses is the same one that comes up every time a small cultural area is seen from a larger one. We can go to a completely different latitude and once again find the problem in South America, where the Colombian critic Marta Traba, for example, has taken this view: "I do not believe in 'Colombian art' but in an art which comes from Colombia. The difference between the two is quite obvious. If we say 'Colombian art,' we are implying the common denominator of a group of works and admitting that they are linked with one another by special esthetic characteristics, by 'Colombian' characteristics. Yet we know quite well that such characteristics do not exist, nor can they be enunciated in any way."[3]

1. H. I. Schiller, *Communication and Cultural Domination* (White Plains, N.Y., 1976), p. 15.
2. J. Boulton Smith, *Modern Finnish Painting and Graphic Art* (New York, 1970), p. 7.
3. Quoted from J. Franco, *The Modern Culture of Latin America. Society and the Artist* (Harmondsworth, 1970), p. 220 ff.

The ten artists in this exhibition do not give us examples of Scandinavian art, but of different forms of art which have manifested themselves in Scandinavia in recent years. Is this how it really is? There is, after all, also art which in different ways is conditioned by certain basic national circumstances. So we can say that Olli Lyytikäinen's work has roots in the fantastic Finnish narrative tradition, or that Bård Breivik's feeling for materials has a similar background in the admirable Norwegian handicraft tradition. At the same time, these elements have long since entered into a symbiotic relationship with certain features in the development of modernism.

Tradition does play a role, and it should. But for avant-garde art, it is considered throughout Scandinavia as very dominating and onerous. It is grappling with tradition in an attempt to transcend it which creates the true "tension zone" in this art from Scandinavia—or Scandinavian art! The Norwegian painter Christian Krohg (1852–1925) supposedly said: "All national art is bad, all good art is national." It is interesting that the view was also voiced by the Danish painter Harald Giersing (1881–1927), who expressed it this way: "All good art is national, not all national art is good." The quotation is just as famous in Danish art history as it is in Norwegian, and Giersing's version was one to which Asger Jorn (1914–1973), characteristically enough, often returned.

For many years, Jorn worked on an enormous documentation, in 28 volumes, of *10,000 Years of Scandinavian Folk Art* (only one preliminary volume of which was finished). There was "a Scandinavian vision of art" which the international artist Jorn wholeheartedly acknowledged. And he believed (in the middle of the 1960s) that a new age was about to begin, when "a dawning understanding will prevail that our place in world culture is not identical with what we accept from abroad, but with what we ourselves are able to produce, whether this is large or small, a recognition that we intellectually possess only what we give away."[4]

Tradition plays a role, and not just up to Jorn, but even farther. Both of the Danish participants in this exhibition, Per Kirkeby and Bjørn Nørgaard, have numerous references in Danish art history, and both, at some time or other, have passed the Danish neoclassic sculptor Thorvaldsen.

The role played by tradition for young Scandinavian artists today (and along with it, the traditional attitude in the milieu toward which they must take a stand) is perhaps best summarized in statements made by two other participants in the exhibition. Paul Osipow: "I believe it is better to experience opposition than it is to meet with indifference." And Arvid Pettersen: "Tradition has haunted Norwegian art. It has remained more of a straightjacket than a source on which to draw. It has come to mean constraint, but it is your duty to derive the most from it and bring something else back to it instead. In other words, it is a question of a process which revitalizes tradition."

The official picture

What links the Scandinavian countries together from another aspect is a largely common concept of cultural policy. There is an extended view of culture: as many people as possible should have access to art, and artists should be supported as well as possible under given (economic) conditions. Gradually, the artist's role has been afforded increasing respect and understanding, and this can be seen in the extent of the state subsidy systems which aim at giving artists orderly and secure conditions under which to do their creative work. The Norwegian national budget for 1982 on a whole follows the zero growth principle, but nonetheless includes a twenty percent increase over the previous year for the cultural

4. From his "preliminary description of the outline and plan for the publication of the work *10,000 Years of Scandinavian Folk Art*," n.d.

sector. The higher priority placed on culture is not as clear in the other countries, but good will is there. The problem is that good will is often ineffective. And good will simply doesn't extend as far as experimental art.

A leading Finnish civil servant recently told me that artists' social standing is higher than their income: people value their artists. But in spite of a major effort on the part of politicians, subsidy systems have not been able to keep up with inflation and the general rise in expenditures. Creative artists, above all, have become pauperized as a result. This has been realized in all of Scandinavia, and it underlies all efforts to create reasonable economic conditions for artists. Artists represent a low-wage occupation, a state of affairs not at all in keeping with their importance for national culture.

It is difficult to understand cultural life in Scandinavia without some insight into the relationship between artist and society in this respect. For an American observer, a number of features of the established subsidy systems must seem almost exotic (if we can use the word "exotic" in this connection!). But it must be stressed that we have different, and stricter, tax regulations. Scandinavia does not have the same firm foundation of interested collectors, and there are none of the same enticing tax deductions, which make the collector an important intermediate link between artists and museums.

The Act on the Danish State Art Foundation states by way of introduction that it has "as its global work to promote Danish creative art." Promoting creative art is also the primary goal in the other countries. At present, Norway and Sweden have worked toward it most consistently. The very extensive results we see there must be credited in no small measure to the effective trade unions, the artists' organizations.

Denmark is the only one of the five countries which has a separate ministry of cultural affairs, founded in 1961. Subordinate to it is the Danish State Art Foundation, whose various committees (which sit for three years at a time) award three-year grants especially to talented young artists, and once-only grants which can be considered production and project subsidies. The Foundation also purchases works of art for public institutions and museums, pays for art works for state buildings, and provides important subsidies for municipal and other public buildings. Finally, there are lifelong payments, testimonial gifts, to a number of creative artists who have made a significant contribution in their field.

Variations on this model form the basis for the policies of the other countries. Cultural subsidies in *Finland* are given by the National Art Council, whose members are also appointed for three years at a time. Artists' grants, for one, three and five years at a time, and project grants are taken from funds partly budgeted by the state, partly from the proceeds of the Finnish Slot Machine Association. The grants are tax-free. If artists' salaries had been adopted, they would have been taxed as normal income. There are also a number of artists' pensions.

The state also finances art schools and colleges, gives extensive support to museums, though on the regional level there is a system of joint state and municipal support.

A "provincial artist" experiment was carried out during the 1970s. Artists from various fields worked in the different provinces partly with their own creative work, partly with teaching and cultural work in a broader sense. The experiment has been important in decentralizing culture, which now plays a growing role on the local level. The results of the experiment were so favorable that a law was passed on the program in 1981.

The question of an artist's salary along the same lines as those paid in Norway and Sweden has been discussed in Finland. Proposals have been made, but the time is not yet ripe for such a system. However, several fifteenyear grants with the right to a pension have recently been awarded for the first time.

The criterion of security is an important one—above all increased social security for artists—and the proposals which have been made primarily concern creative artists, and, to a lesser extent, performing artists who hold some kind of position in theaters, orchestras, etc.

In *Iceland*, testimonial salaries are paid to a small number of artists. They are granted for one year at a time, but can in practice be considered permanent. In addition, there are two types of work grant. The smaller grant corresponds to perhaps two to three months' salary. The Federation of Icelandic Artists wants to reduce the number of such grants and at the same time increase the payments made. The other type is grants given for three to nine months.

Everyone agrees that a study should be made of grant and subsidy systems in force in the other countries, and there was an almost historic situation last year when all artists' associations in Iceland met for the first time to devise a common cultural policy.

It should also be mentioned that Iceland has a two percent rule for works of art for school buildings. Under this rule, two percent of the cost of the building should be spent on works of art for it. It has been proposed that the same rule be applied to all state buildings.

The most thoroughgoing analyses of artists' conditions, and of the state's responsibility toward artists as a profession, have been undertaken in Norway and Sweden. In many respects, *Norway* has gone farther than other countries in Scandinavia in meeting artists' demands, and the radical solutions to the problem which have been adopted can be linked with the recognition that until the seventies, Norway was far behind the other countries in cultural policy.[5]

The central points in the Norwegian subsidy system are:
1) a system of guaranteed incomes
2) the right for artists to negotiate
3) the development of (collective) compensation systems.

Let me quickly describe what these points entail since in many respects they represent a new way of thinking about the relationship between state and artist.

1) A system of guaranteed incomes has been in force since 1977, and covers active artists who have done high-quality work. The guaranteed income is divided into segments. The maximum sum can be paid only to those who do not have any income of their own. Applications are approved by a grants committee.

This can be difficult enough. Norway has something like 4,000 creative and performing artists with a position which qualifies them to subsidies under this system. Pictorial artists make up the largest group by far, one-quarter of the total. It should be pointed out that artists who want a guaranteed income do not have to be members of any organization.

In 1981 nearly 250 pictorial artists had a guaranteed income. This year the average payment made to this group under the system was just under 40,000 Norwegian crowns, slightly over $5000.

2) The Norwegians recognized very soon that artists had a natural right to negotiate their economic conditions. The state took upon itself the role of the opposite party, and at the same time gave negotiating rights to the national organizations which represent the groups of artists involved. This right covers negotiations on compensation for the use of artists' work, on rules and guidelines for state grants systems and guaranteed incomes, on remuneration for commissions, etc.

The agreements which have been made are uniquely Norwegian and have not yet been implemented in the other countries.

5. There is a comprehensive description in German of the development of art policies and subsidy systems from a slightly different angle in J. Brockmann, "Zur sozialen Lage der bildende Künstler in Norwegen," *Heute Norwegen Heute*, exhibition catalogue (Kiel and Darmstadt, 1981).

3) The rationale of the compensation systems is the agreement that artists have the right to remuneration for the use of their works by the state as long as it is still the artists' property. Compensation is naturally made for all exhibitions which are organized or financed by the state. Compensation goes direct to the artist and is calculated according to fixed rates which are subject to price-index adjustment.

Another point still under discussion is what literally translates as "display compensation." This was formulated by pictorial artists who point out, among other things, that other creative artists, such as composers and authors, are paid royalties for the use of their works. Only very few pictorial artists can live from the sale of their works. This is why they want compensation—in addition to the kinds already mentioned—for the use of their work after it is sold.

But the question is problematic and has not yet been resolved. As it is, exhibition budgets are already strained. All of the institutions and authorities involved have had their budgets raised, and expenditures for exhibition compensation will henceforth be part of the normal expenses in an exhibition budget.

Since compensation is in addition calculated in proportion to the value of the work, prestigious exhibitions with prestigious artists could be an expensive business. Having work exhibited at the Venice Biennale can give a Norwegian artist an easy extra income, without him having to lift a finger. But a colleague in Iceland, who cannot enjoy the same favorable system, can risk having to pay something out of his own pocket.

The interesting thing about the Norwegian compensation systems is that they are collective and have a clear social and solidary intent. In the organizations' first negotiations with the state, their goal was to have all artists paid equally large subsidies. This solidary view has been relinquished now, and today the criterion of quality has been taken up again in evaluations. But it is also the individual artist's work and contribution which are the prerequisites for membership in the organizations.

One special feature of the situation in Norway is the artists' own important role in the mediation of art works. Through their own organization and exhibition institutions, they have contributed to the cultural decentralization which is important in a country with such difficult geographic conditions as Norway's. Artists, together with other art experts, also make up the majority in juries judging competitions for works of art for public buildings, etc. Those who are going to use the buildings are also on the jury, but they can never constitute a majority.

The state has declared its intention to use two percent of the budget of state buildings for buying works of art, but the figure has hardly been more than one percent in practice because of general economic difficulties.

The main trend is clear now, but new ideas have been put forward since Norway's change of government. The new conservative government might change the current situation somewhat, since the party has always taken a special stand in the debate over the state's responsibility toward artists. It has been against the guaranteed income system and preferred testimonial grants paid according to artistic criteria. The conservatives have criticized the guaranteed income systems for being socially oriented, without any regard for artistic quality.

There is probably the general view in the other Scandinavian countries that Norway has a strong arts policy, but that the quality of the work done there in the pictorial arts is rather poor.

In *Sweden*, there is an even stronger realization (of what must also be a problem in Norway) that there are a great many (too many?) artists. The official figure is 5000—6000

pictorial artists as opposed to some 1000 writers, for example. Around 3000 of them are members of the KRO, the Swedish Artists' National Organization. The figure naturally indicates that enormous amounts would have to be set aside in the budget if Swedish artists were to have guarantee systems and compensation similar to those of their Norwegian colleagues.

At present, there are still grants for one, two and five years in addition to about a hundred artists' grants (with pictorial artists accounting for two-thirds of them) in the form of a yearly remuneration from the state calculated according to the artist's own income.

But since the middle of the 1970s, considerable progress has been made in two areas which are perhaps the artists' most important demands of the state:

1) Exhibition compensation. As in Norway, compensation is given for works of art in exhibitions which are under the auspices of the state or receive state aid. But this has already become a problem, since museums have not received compensation in the form of increased exhibition budgets and can thus be forced to take the necessary amounts from their acquisitions accounts, for example.

There has been a discussion of whether this should hold good for all public exhibitions, so that the state paid part, while the municipalities covered the preliminary expenses. This system has never been adopted, and even though the Artists' Organization is still negotiating with the municipalities, the state has shelved the idea.

2) "Display compensation." The basic view is the same held in Norway that pictorial artists have the right to compensation for the public use (i.e. being on display and seen) of their works. Artists want to get away from what they consider public welfare—grants, etc.—and instead want remuneration for work they have done.

It has been proposed that a new Pictorial Artists' Fund be established, to which both "display compensation" and existing grants be transferred. A tax on audio tapes and video cassettes is also being levied in Sweden, which is expected to bring in 40–50 million Swedish crowns (c. $8 million) annually. Five million crowns (c. $834,000) of this would be transferred to the Pictorial Artists' Fund, which, with additional money from the State, would have 17–19 million crowns (c. $3 million) at its disposal. A heated debate is now in progress over how this money would be administered. Many have proposed the Norwegian model of a guaranteed income.

State subsidies for works of art for state buildings vary from year to year. At present, the available funds amount to somewhat over 13 million Swedish crowns ($2.2 million) per year. Subsidies are not paid as a fixed percentage, but as a lump sum. The subsidies are granted on a case-by-case basis, according to the building's function, location, etc. The individual municipalities are free to decide how much they want to spend on works of art.

Financing for works of art for state buildings is channelled through the Swedish National Arts Council. The Council is made up entirely of artists who sit for a period of three years. They administer the funds and select project leaders for the various buildings.

There is a joint council which sees to it that those who will use the buildings are given the necessary information on the projects. The council debates the often minutely formulated demands made of the artist by the party commissioning the work of art. It thus carries out important informative work, which in most cases has resulted in a fine exchange of viewpoints on art's function in its specific surroundings. This joint council has, in fact, given the lie to fears of indirect censorship. Sweden has a public participation law which has not, however, had any direct significance for pictorial art in public buildings. There have been a few examples in Sweden and Norway of the public opposing the works of art they have been given, and there is little doubt that if the democratization of the decision-

making processes regarding art in public places is carried much further, there will be a risk of tame and insignificant art, a kind of visual Muzak which pretties up public milieux and doesn't offend anyone. As it is, one can point out many important and interesting results, among them several of the decorations in Stockholm's subway stations, which are often cited in showing how well this system works.

It is tempting to make comparisons with conditions in America, where the Art in Architecture program of the seventies, at least to a Scandinavian observer, seems to have worked more openly and with less bias with a view to new art. But there is hardly any parallel in Scandinavia to the belief expressed by the program's administrator, Jay Solomon, that the government has a responsibility "to experiment, to innovate, to be a testing ground for new ideas."[6] Opposed to this belief is that strange public participation law, a grand example of misunderstood democracy, where every view will be considered, resulting in art based on compromises and cold calculation.

There are other problems. They are Sweden's problems, but also indirectly involve the other countries: it is impossible in the eighties to live up to the cultural programs which the state and its bureaucrats established in the seventies. The economic crisis means disappointed prospects for artists' organizations. The National Council for Cultural Affairs, which in Sweden is the single authority for nearly the whole cultural field, admits that the least progress has been made in the pictorial arts. Proposals such as "display compensation" came into the picture so late as far as the Council was concerned that funds had already been earmarked or used. Pictorial artists on the whole undoubtedly are more estranged from politicians than other groups of artists. And unlike writers, they do not have a tradition of formulating their cultural policies.

One can say in summary that cultural policy is built upon highly diffuse artistic criteria. It is, above all, social policy, with social security as its underlying rationale. Artists want the same social and economic security as the rest of society. The danger is that organizational politics will overshadow other considerations. Has increased social security helped bring artists and the rest of society closer together? "Display compensation" and other forms of support have, it is true, raised the artists' income, but hardly society's understanding of how the enormous work which comes out of all this should actually be used. As a leading Swedish civil servant recently remarked to me, artists should rethink their role in society as a whole, and not concentrate only on their economic security.

Somewhere between opposition and indifference—the unofficial picture

Improved economic conditions for artists must naturally be seen as an unmixed blessing. But the various subsidy systems have also meant an administration and a structuring which make many young Scandinavian artists feel that their milieu has become too bureaucratic. Second-rate artists are enthusiastic about joining organizations, and become "apparatchiks," while artists who have long since made a success of it stay away because they can manage very well on their own. Young artists just making a breakthrough or looking for alternative forms of expression are not given enough backing by any party, and become odd men out.

But good finances are not enough to make a good artistic environment. And neither are strong trade unions. Many different factors interact at a specific time and release energy and activity. It is worth noting that now, in the beginning of the eighties, we are finding an optimism and an expectation of interesting lines of development in Scandinavia in the upcoming years. The level of information is much higher. Good young artists see their

6. Quoted in Joshua C. Taylor, *Across the Nation. Fine Art for Federal Buildings, 1972–1979*, exhibition catalogue (Washington, D.C., 1980), p. 4.

23

work as part of larger developments which are not decided by national borders alone. Important interaction is taking place within this specific Scandinavian field. But artists work in an area where conservatism, opposition and indifference help decide the framework and condition results.

Exhibitions can be seen as a direct indicator. It stands to reason that much that has happened in Denmark, for example, has been obstructed by traditional features in the exhibition system. Tradition has been cemented because of the particular, almost unique, Danish phenomenon: artists' groups and their annual exhibitions. Though these groups were originally founded by artists who had a kinship or common esthetic, they have come to carry on traditional standards unchallenged. Renewal in the form of new members or guests almost always occurs within the given framework. The groups' exhibitions are the most important events in the Danish art world. The joint platform gives the artists themselves greater attention than they would have received if they had exhibited their works in one-man shows.

The groups have primarily aimed at attracting a bourgeois public of art lovers and express an inertia in the milieu which has also delayed an understanding of new trends. This is actually surprising, since Danish art in the sixties and seventies was fairly rich in opposition groups interested in current ideas and views.

There are at least two reasons why avant-garde artists' activities at this time were not more effective. First of all, a significant part of these activities took the form of happenings and performances, which had a limited public and which were not sufficiently documented. Secondly, the abstract movement in the late thirties and forties and the founding of the COBRA group constituted such a breakthrough that they have dominated Danish art ever since. When we in Denmark speak of "modern art," it is still synonymous with the work of these artists, even though they are all around seventy years of age.

It is this generation on which the public has concentrated its interest. It is they who have been written about most. Their works have been safe investments for the liberal bourgeoisie which wants to collect modern art without daring to go right out to the front.

These are factors which, as I mentioned, to a certain extent overshadow what at times was the highly vigorous and energetic milieu in Copenhagen during the past two decades. There are active links with German art, in particular, in the wake of the COBRA movement. The links can be traced to the SPUR group in West Germany, to the international situationist movement and to Fluxus. And, as is the case in the other Scandinavian countries, there are a couple of small galleries which serve as catalysts.

German-born Arthur Køpcke (1928−1977)[7] had a little gallery in Copenhagen from the beginning of the fifties which he ran as a sideline to his own important artistic work. Through it, he channeled such trends as le Nouveau Réalisme and Fluxus into the Danish art world, and it was Køpcke who introduced Denmark to Piero Manzoni. (This had the unusual result that Manzoni, with the intervention of a liberal patron in the summer of 1960, was able to work in Herning, in Jutland, and there carried out his longest line−7200 meters−which, sealed in a zinc box, still stands as one of the town's monuments!) The Fluxus group became known in the early sixties, and George Maciunas, Emmett Williams, Dick Higgins, Alison Knowles and Ben Patterson were active in Copenhagen in 1962, the year in which the group also worked in Germany and London. The year after, John Cage and David Tudor took part in a Fluxus festival.

But it is contacts with Germany which have left lasting traces. The meeting between young Danish artists−Bjørn Nørgaard and Per Kirkeby among them−and Beuys was an expression of interaction. The Danish composer Henning Christiansen worked closely

7. About Køpcke, see *North*, no. 7/8 (Roskilde 1979). Text in Danish and English.

together with Beuys and wrote music for "Eurasienstab/fluxorum organum" and other pieces. Beuys performed part of his "Sibirische Symphonie"—"Eurasia"—in Copenhagen in 1966. The same year, Christiansen and Nørgaard participated together with Beuys in a performance of "Manresa" at the Galerie Schmela in Düsseldorf.[8]

The Experimental Art School—an alternative school opposed to the teaching at the Royal Academy of Fine Arts—was very important for developments in the sixties. It emphasized the experimental situation and collective forms of work, and for some years set the framework for a highly intense milieu.

This is not the place to document the postwar art history of Denmark. The examples I have given can suffice to show the fruitful and positive side of being "a border area between Scandinavia and the rest of Europe." This is bound up with the geographic proximity to the Continent and the fairly open atmosphere in Copenhagen. Young Danish artists today are keeping their connections with Germany. Many of them exhibit their works there, while others work there themselves. It is not surprising that German "neo-expressionism" has made a rapid breakthrough in Danish art as well.

The level of activity is different, and has a different character now than it did in the sixties. Artistically, we find a pluralism and an open situation which can be fruitful in the long run. Young artists have a great need for work grants and other subsidies from the Danish State Art Foundation.

However, the number of grants is being cut, and the minimum amount raised, because of the current recession and inflation. Pictorial artists are calling in vain for an effective organization which can negotiate directly with the state. Last year, a Danish sculptor tried to bring attention to the problem of lack of support for art when he blew up one of his granite sculptures. Judging from the reaction, it was a futile act.

Fairly few galleries exhibit completely new art and systematically follow new trends. Some official and semiofficial institutions purchase in a terribly traditional vein, and do not give any real support to experimental art. Company art societies are regular buyers at the large exhibitions in Denmark, as in the rest of Scandinavia, but they also keep to well-known artists and help maintain the status quo.

There has been a fairly intense debate in Denmark during the past couple of years about the founding of a museum of modern art in Copenhagen. But not even the most modest proposals can be carried out during the present recession, and nobody has thought about how an even tolerable collection could be amassed and expanded further with the prevailing international price level.

But Denmark already has the Louisiana Museum outside Copenhagen. Its collection has become quite significant over the years and its highly active exhibition policies have provided running information on international developments from the sixties onwards. Many of these exhibitions have had an important effect on the Danish art world.

The large museums in Scandinavia rarely assume the role of a window on the current world. They are traditional institutions and must thus retain a historical perspective. The Henie-Onstad Art Center outside Oslo is the Norwegian parallel to Louisiana as far as its facilities and location go, but has probably never had the same significance for art life in Norway. The most interesting in this connection is Stockholm's Moderna Museet, which directly brought about a very high level of activity in Swedish art in the sixties. American Pop Art was shown there at a time when it was still in the making, and the museum also came to play a large role later as an inspirer and instigator. The museum's importance was also felt in Finland, since it was easy for artists to go to Stockholm for important exhibitions.

8. Cf. C. Tisdall, *Joseph Beuys*, exhibition catalogue (The Solomon R. Guggenheim Museum, New York, 1979), pp. 105, 110.

Sweden is largely similar to Denmark in its openness to new trends in art. Seen from neighboring countries, Swedish art has held a clear avant-garde position. Swedish artists have set themselves into the international context more rapidly than artists in the rest of Scandinavia.[9] There is also a personal link to American art through Claes Oldenburg and Öyvind Fahlström, and this is incidentally a link which Swedish art is trying to maintain. Sweden is the only country in Scandinavia (but Denmark might be able to join it) to have a studio at P.S. 1 in New York and an annual grant to cover a stay there.

One can also see parts of this development as "trendy." Some people feel that new trends are being accepted too quickly—in a hunt for something new—only to be left again if they can't make it locally or be developed individually. There are clear signs of eclecticism throughout the sixties and seventies in Swedish art, but on the personal level, there is an attitude of relativism which lets the individual more or less change expression and views unhindered.

Geographic problems play a role in Sweden, as they do in Norway. Stockholm holds an obviously dominant place, especially now, with the marked increase in the number of galleries there (around a hundred in the Stockholm area alone). But regional centers such as Gothenburg and Malmö, whose proximity to Copenhagen is not an insignificant factor, partly counterbalance Stockholm.

The provincial museums do a great deal on their own initiative for young art. Organizational politics have, however, to a certain extent backfired on the artists themselves. The "display compensation" I mentioned before also eats into exhibition budgets.

One can sense a vital and almost anarchistic situation in young artists' circles. They are experimenting in many directions, and here, too, the currently highly saleable German neo-expressionism has made a major impact. The German artist Jörg Immendorff was a guest teacher at the College of Art in 1981, and this can be seen as a sign of the direction interests are taking today. It is indisputable that he has already left his mark in Sweden.

The problem for young artists is, says one of the teachers at the school, that they go into an experimental situation with a suspended awareness of history. They have not brought their historical materiel out to the front, and thus lack certain necessary premises for the work they are doing. Considering how the rest of Scandinavia earlier viewed the situation in Sweden, it is interesting to note that young artists are more interested now in what is happening in neighboring countries, and that they are watching developments in Norway, for example, with great attention.

A young Finnish artist who has been working in avant-garde art for several years speaks of what he calls "a policy of exhaustion." How is it possible, he wonders, that in Finland one can reach a certain level, receive support and favor to a certain point, and then no further. You can develop yourself and reach an acceptable level in your own development. But there is never anyone who is standing ready to catapult you further, out into a larger context.

It is regrettable if this is one of the consequences of the democratization of art life. Nonetheless, this is exactly what many artists and museum people are thinking about. All expect to get their slice of the cake—in other words of the subsidy systems—and everything is leveled out: the milieu becomes horizontal. It is no less important that Finnish isolation, the unwillingness to open up to international culture, is considered a modern dilemma by many young artists.

Cultural isolation is part of the Finnish experience. Finland's location, far from the mainstream, contributes to what many Finns openly call a national inferiority complex. History shows that the Finns are not outgoing, but that they defend their territory. They

9. There is an up-to-date introduction to modern Swedish art: Olle Granath, *Another Light. Swedish Art Since 1945* (published by the Swedish Institute, n.d.). New, revised edition, 1982.

are slow to react to influences from abroad, but on the other hand safeguard their deep roots in the Finnish intellectual tradition. We wait a long time before we react, says one Finnish artist. And this is also true of modern art. The major trends come late and in highly modified form to Finland, but are well received. The Finns are, he says, not good at confronting artistic problems directly. Everything is taken indirectly, if not exactly hostilely.

The Art Museum of the Ateneum in Helsinki held three major informative exhibitions several years ago, aimed at orienting the Finns towards tendencies in new international art. These *Ars 61, 69* and *74* all met with scepticism and opposition, but there should in fact be more such initiatives. They are just so difficult to realize. There are cultural agreements with countries in eastern Europe, whose exhibitions programs run smoothly, but there is no such channel for similar exhibitions from the West. This is Finland's exhibition system on the official level, and it is here the distortion of information comes, showing an overdose of exhibitions from the East.

The seventies was one of the most boring periods in the recent history of Finnish art. After 1968, we can see a polarization in society which also brought party politics into culture. Pictorial art was dominated in the following years by a wave of social realism. Pictures revelled in an old, rustic reality which was a mishmash of false show and nostalgia. We can see this social realism of a kind as a consequence of the political climate. Within pictorial art, it was alone counterbalanced by good Finnish constructivism.

As a direct consequence of the move to the left, some artists started a little organization in 1968 opposed to the large and highly bureaucratic Artists' Association, which was considered very traditional and conservative. Later, the new organization merged with the old one, and helped change attitudes there. Nonetheless, very old-fashioned questions are still being asked regarding art and its function in society, and many young artists find it difficult to get support within the Artists' Association. It is more interested in getting state subsidies for its members than it is in art's role in society. But an artist outside the organization can have difficulty in obtaining the necessary grants and can easily be boycotted or kept out of important activities.

Where has new art been these past years? The *Ars* exhibitions at the Art Museum of the Ateneum did have their effect—no doubt about it. The Free Art School in Helsinki has also opened the way for an understanding of new problematics of painting. There is now a new generation of artists of which much is expected, with women artists well represented.

The *Ars* exhibitions gave modern art a certain urgent currency, a challenge from outside to the local milieu. The response came from a little group of artists which unfortunately never gained the place it deserved in the seventies, something which is only now being realized in retrospect. It was the true avant-garde which manifested itself at Cheap Thrills, a little gallery opened in 1971 by the artist, theoretician and writer Jan Olof Mallander and kept going until 1977 in spite of economic difficulties. Mallander later called it "the good bad conscience of Finnish art."[10]

The gallery served as a platform for a group of artists which had no other place to exhibit its work and which also fell outside the categories Finnish exhibitions could think of accepting at the time. The artists called themselves the Reapers. Olli Lyytikäinen made his debut and had his most important early exhibitions at the gallery. There were also exhibitions of work by kindred artists from the rest of Scandinavia, and finally an attempt was made to introduce international art. Important contacts were established with other small but important art galleries elsewhere in Scandinavia: Gallery I in Bergen and Gallery SÚM in Reykjavik.

It must seem natural now that Cheap Thrills had to go under in the battle between the

10. A description of the gallery's history can be found in *North-Information 80* (1979). Text in Swedish and English.

dominating trends, realism and constructivism, but just as natural, against this background, that the gallery had emerged. Cheap Thrills represented the little tendency to alarm which emphasized that not everything was as good or as self-sufficient as people wanted to pretend.

Many young Finnish artists feel very much like the nineteenth-century statesman who stressed that the Finns were neither Swedes nor Russians: they should be themselves, uniquely placed as they are between East and West. A new generation of artists is about to break down Finland's isolation. There is a more open atmosphere and fresher air in the debate.

A largely similar development can also be found in Norwegian art today. The events of 1968 marked an epoch everywhere, in Norway no less than in Finland. And the Norwegian situation is perhaps also the one which is most like the Finnish: there are above all the same powerful ties with tradition.

The many artist-run activities and powerful trade organizations which have helped bring about results in negotiations with the state are on one level an expression of a close-knit national art life. And self-sufficiency and the national effort are dramatically and demonstratively expressed in the large decorations for the Oslo Town Hall: pictorial art used as a national manifestation.

Perhaps because of powerful organizations, set patterns and relative predictability in the art world, established artists quickly become staid and languid, and stop taking the lead, notes a young Norwegian artist. And this is actually strange, since Oslo has a bohemian tradition which earlier gave the city a vital and significant cultural atmosphere.

Oslo is still the important center it was. This is where established artists settle. The number of galleries has increased considerably in recent years, and there is a fairly active exhibition schedule. But because of its geography, Norway has a decentralized art world, where regional activities and differences are expressed, and where mediation in general is a key concept in cultural policy. Each year, regional exhibitions are arranged by the district organizations of pictorial artists in cooperation with local art societies. In the later seventies, six artists' centers were established in various parts of the country which run galleries and exhibitions and disseminate other kinds of information. All are run by artists themselves.

Art education is to a certain extent decentralized, too, since the State Art Academy in Oslo has now been joined by the Vestlandet Art Academy (in Bergen), which became a state institution in 1981, and the Art School in Trondheim. It is difficult to catch sight from Oslo of much of what is happening in the regional centers. To get into this milieu, to make oneself known as a young artist at all, evidently involves joining a process which is highly structured. Both the Norwegian representatives in this exhibition, Bård Breivik and Arvid Pettersen, are examples of how it can also be done, in a true interplay with essential factors outside the organizations.

Both artists come from Bergen, which has traditionally had a highly localized and very reactionary cultural life, without any major external influences. And contacts with Oslo have been traditionally distant. Many of Bergen's young artists have gone to the Royal Academy of Fine Arts in Copenhagen for their education, instead of going to Oslo. Danish artists served as visiting teachers in Bergen even before the school was given its present status.

A group of artists joined forces in the midst of this provincial isolation in the late sixties. The result of their work together was a progressive interplay, a release of energy based on work with impulses from without and on mutual openness in the exchange and discussion

of information. At the same time, certain excellent institutes within the humanities were very much in evidence at the University, and a new, young generation of writers began to emerge in Bergen. In other words, a stimulating milieu which involved science, literature, art and music gave activities a new direction and energy. And none of this was burdened by tradition, as in Oslo.

The Flash (Lyn) group emerged, which established Gallery I without any real economic basis in 1969. The group's own artists exhibited their works there, but the gallery also held Scandinavian exhibitions and worked in cooperation with Mallander's Cheap Thrills in Helsinki and the SÚM group in Iceland. Close professional and social contacts were important, and the interplay between theory and practice was utilized in the persistent efforts to build up the Vestlandet Art Academy, where new teaching methods were adopted. The break with traditional attitudes was obvious to all when the Flash group made a prominent debut in Oslo with the controversial exhibition *Bellevue, Bellevue* in 1972.[11]

Iceland lies quite apart geographically from the rest of Scandinavia. This isolation has, on the other hand, meant that it has been equally natural for Icelanders to seek out contacts in the United States and Britain and on the European continent, as it has for them to seek them in the rest of Scandinavia. The last few generations of Icelandic artists have battled heavy odds and managed to create a milieu and to gain a central place in the European art of the past decade. These artists have, it is true, had a better forum abroad than in Iceland. Young artists feel as if they are working in a vacuum back home; in any case, they do not meet with any real sympathy. There is a generation gap and a lack of understanding between them and older artists, and between them and the public. This is a strange indifference when we consider the level of activity and the quality of the work being done.

In spite of difficult economic conditions, Iceland has a vital art world. Critic Adalsteinn Ingolfsson has registered something like 170 exhibitions annually for the past couple of years. But avant-garde art accounts for a modest fraction of the official picture.

Naturally, this is an important reason why Icelandic artists have preferred to settle in other places. Earlier, Copenhagen was a natural destination, but some artists also went to France and Germany. The Gudmundsson brothers' decision to move to Amsterdam was of decisive importance for new Icelandic art, just as important for what is happening nowadays as what the great Icelandic writer Halldór Laxness called "the Danish-Icelandic divan" was for the artists of the thirties and forties. In recent years, the Academy in Maastricht could almost be considered an Icelandic school. Something between twenty and twentyfive Icelandic artists have been trained there and, at the moment, the Academy still has a handful of Icelandic students.

The very young generation is taking a chance and staying home. A circle of interested people has after all created something which is becoming a milieu. And artists can join together in opposition to the official milieu, which has largely let them down.

One interesting expression of this is the Living Art Museum (Nýlistasafn), which was started by a group of older artists from the influential SÚM group together with younger artists in an attempt to preserve and document the central segment of new Icelandic art which SÚM represents.

The Living Art Museum received a large donation of work by Dieter Rot (who was in Iceland almost without interruption from 1957 to 1964), and works by Daniel Spoerri, Richard Hamilton, Joseph Beuys and other artists who had been in Iceland and worked together with SÚM artists.

The museum is now trying to use its modest funds to make a systematic documentation

11. See "Norwegian Contemporary Art," *North* No. 10–11 (1982). Text in Danish, Norwegian and English.

of the art of the sixties in Iceland. Young artists can join the museum by simply giving one piece of work to it annually. The Living Art Museum now has good exhibition facilities and arranges regular showings.

SÚM emerged from a dissatisfaction with the set, conservative and worn-out art milieu. The artists who formed the association "had in common dissatisfaction and society's contempt, but not very much else," as Gudbergur Bergsson expressed it. "All SÚM art is permeated with Icelandic eccentricity, the only characteristic and independent attitude that has been held in Iceland, an attitude of isolation, the individual, and the outlaw."[12]

These are perhaps not features of the characteristic and easily recognizable Icelandic version of conceptual art in the seventies. This special, minimal, laconic, but also lyrical Icelandic expression was accelerated by a kinship with certain Dutch conceptual artists, based on personal relationships and a free exchange of experiences (Sigurdur Gudmundsson works in The Netherlands while Douwe Jan Bakker works in Iceland) and contacts which reveal a kindred mentality.

The central force in art these past few years is Magnús Pálsson. It would be difficult to overestimate his importance as an artist and as a teacher of the new generation. As a teacher at the Icelandic College of Arts and Crafts in Reykjavik in the seventies, he among other things arranged to invite visiting teachers—Robert Filliou, Dieter Rot, Bakker and Dick Higgins are names which give a certain impression of the directions in which things were going—even though finances only allowed a short stay for each artist. Now there are plans to establish a stop-over program, in which artists on their way between Europe and the United States can "hop off" in Iceland and give lectures.

It was also Pálsson who took the initiative in founding the Mobile Summer Workshop, a workshop planned on generous lines for conceptual art. It can only be hoped that the experiment will do better than the Experimental Environment arrangement, which was held outside Reykjavik in the summer of 1980. Young Scandinavian artists working with environmental art were supposed to meet there and carrut a number of projects. Later they were to implement their ideas and work in localities in the rest of Scandinavia. But without a solid organization and financing, the experiment partly misfired.

Halldór Laxness, in his little book about the painter Svavar Gudnason, tells of a visit Alfred Barr, Jr., once made to Reykjavik. He wanted to see works by the Icelandic painter Jón Stefánsson, who, together with other talented Scandinavians, studied with Matisse in the years before the First World War. Barr wanted to see how an Icelandic artist had reacted to such influences. He was shown "some pictures of overworked cliffs and glaciers, shaggy horses and seascapes with breakers as thick as oatmeal [and] hurried to look away without saying a word."

"Nonetheless," continued Laxness, "it should be possible for an American to comprehend the incomprehensible in the idea that Jón Stefánsson or some other Scandinavian, or for that matter also some American, regardless how gifted, could be made into a Matisse no. 2 through a process of training in Paris in 1908, even under Matisse himself."[13]

The good young artists in Scandinavia do not want to be a copy of some contemporary master or other, either. Their field of operation lies at the crossroads between tradition and new creativity, and I would guess that most of them will agree with the Finnish writer Jörn Donner—who writes in Swedish and thinks like a European!—when he says the following in his searching and self-revealing diary: "I consider it an important element in all artistic work to try to question or define national identity, to know what nation one belongs to and why."[14]

Translated by Martha Gaber Abrahamsen

12. "H₂O, Ny Islandsk kunst" [new Icelandic art], exhibition catalogue (1974). Text in Danish, Icelandic and English.
13. H. Laxness, *Svavar Gudnason* (Copenhagen, 1968). Danish text with English summary.
14. *Jag, Jörn Johan Donner född den 5 februari 1933 i Helsingfors, Finland* [I, J. J. D., born February 5, 1933, in Helsinki, Finland] (Helsinki, 1980), p. 60.

I have received information and help from many artists, colleagues and civil servants as I collected the material for this article. They include Tuula Arkio, Bengt von Bonsdorff, J. O. Mallander, Olli Lyytikäinen, Paul Osipow and Kalervo Siikala in Finland; Mats B., Anders Clason, Olle Kåks, Björn Springfeldt and Mailis Stensman in Sweden; Magne Malmanger, Arvid Pettersen and J. Aanderaa in Norway; and Adalsteinn Ingolfsson in Iceland. I would like to thank all of them. I naturally bear full responsibility for the interpretation of all these facts and information.

Bård Breivik

Lars Englund

Hreinn Fridfinnsson

Sigurdur Gudmundsson

Per Kirkeby

Olle Kåks

Olli Lyytikäinen

Bjørn Nørgaard

Paul Osipow

Arvid Pettersen

Bård Breivik

Born 1948 in Bergen, Norway. Lives in Stockholm.
Studies at Bergen College of Art and Crafts 1967–70
and St. Martin's School of Art, London 1970–71.
Co-founder of artists' group LYN (Flash).
Professor at Art Academy of Bergen 1974–79.
Since 1982 professor at College of Art, Stockholm.

ONE MAN SHOWS (selection)
1:1, Gallery 1, Bergen 1974
Gallery Wallner, Malmö, Sweden 1979
Gallery Ahlner, Stockholm 1979
Gallery Dobeloug, Oslo 1979
Gallery Sculptor, Helsinki 1981
Trondheim Art Association, Trondheim, Norway 1981
Gallery Nemo, Kiel, West Germany 1981
Fiber, Henie-Onstad Art Center, Høvikodden, Norway 1981
Fiber, Galerie Aronowitsch, Stockholm 1982
Fiber, Skånska Art Museum, Lund, Sweden 1982

GROUP SHOWS (selection)
Paris Biennale 1975
Eye to Eye, Liljevalchs Art Hall, Stockholm 1976
Norwegian Art of the 70's, The Cultural House, Stockholm 1978
Norwegian Art Today, Kunsthalle, Kiel, West Germany 1981
Matter/Memory, Art Hall, Lund, Sweden 1982; also shown at
 The Artists' House, Oslo, Ateneum, Helsinki, and Charlot-
 tenborg, Copenhagen 1982

SCENOGRAPHY
The Pyramids, a triptych for The New Hall, Moderna Museet,
 Stockholm 1979
TER(R), The Cultural House, Stockholm, and Henie-Onstad
 Art Center, Høvikodden, Norway 1981

REPRESENTED
Moderna Museet, Stockholm
Norwegian Arts Council, Oslo
Bergen Picture Gallery
Malmö Museum, Malmö, Sweden
Nasjonalgalleriet, Oslo
The Art Collection of the City of Oslo
Ateneum, Helsinki
Kunsthalle, Kiel, West Germany
Gothenburg Art Museum, Gothenburg, Sweden
The Henie-Onstad Collection, Høvikodden, Norway

"The following photographs show models, on a scale of 1:4, of the works executed for the exhibition. The hull shape has been my prime object of investigation for three years now, and the process has resulted in works that I have seen in many different contexts and exhibition rooms. My obsession with this shape stems from its 'archetypal' quality; insect, hull, container, building, vehicle. A shape that reminds us of something, some almost forgotten moment. These forms relate in the deepest sense to our perception of time. As constructions, emanating from the mind, they picture our need to shape our culture, and suggest ways of thinking or dreaming. They lay bare levels of abstraction in a specific period of time.

 The tradition of sculpture is very much concerned with mass and solidness of shape, which create a monumental distance. Another tradition stems from the crafting of arti-facts for use. My concern, in these works, is with the field of energy between these two poles, to work with both the mass and the shell."

BÅRD BREIVIK
Untitled I. 1982
Hazel wood
83 × 14 × 14″ (210 × 36 × 36 cm.)
Photo: Carl Henrik Tillberg

BÅRD BREIVIK
Untitled II. 1982
Steel (forged)
83 × 14 × 14″ (210 × 36 × 36 cm.)
Photo: Carl Henrik Tillberg

BÅRD BREIVIK
Untitled III. 1982
Steel (⁴⁄₁₆″ − 8 mm.)
83 × 14 × 9½″ (210 × 36 × 24 cm.)
Photo: Carl Henrik Tillberg

BÅRD BREIVIK
Untitled IV. 1982
Laminated wood and zinc
83 × 14 × 9½″ (210 × 36 × 24 cm.)
Photo: Carl Henrik Tillberg

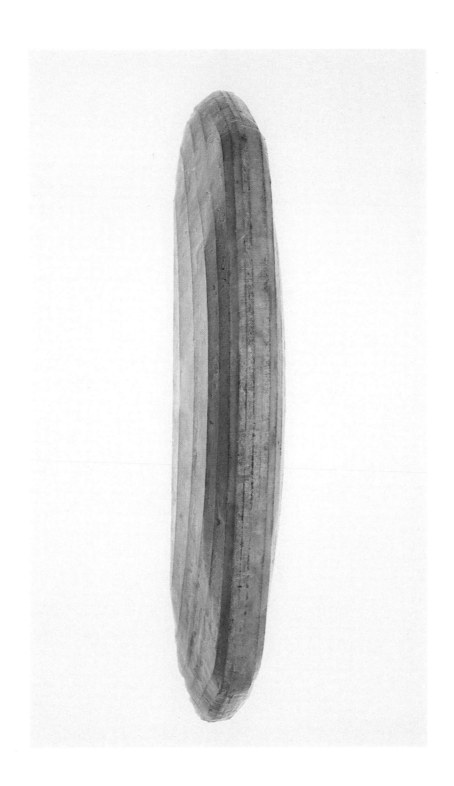

BÅRD BREIVIK
Untitled V. 1982
Mixed media
83 × 14 × 8¼″ (210 × 36 × 21 cm.)
Photo: Carl Henrik Tillberg

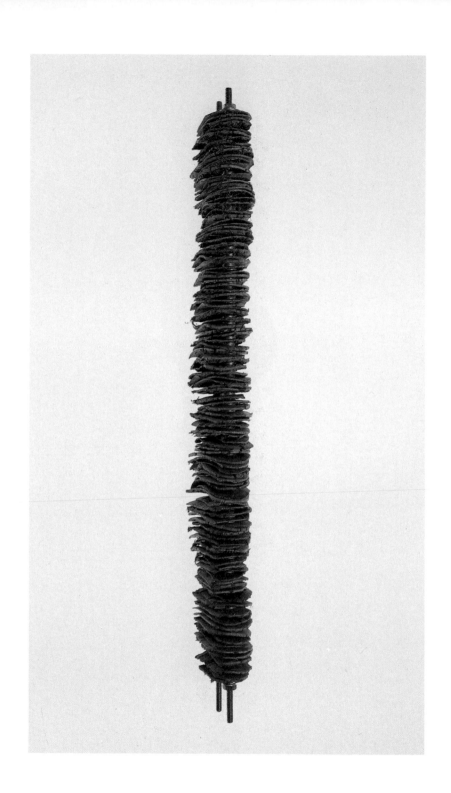

BÅRD BREIVIK
Untitled VI. 1982
Mixed media
83 × 14 × 8¼″ (210 × 36 × 21 cm.)
Photo: Carl Henrik Tillberg

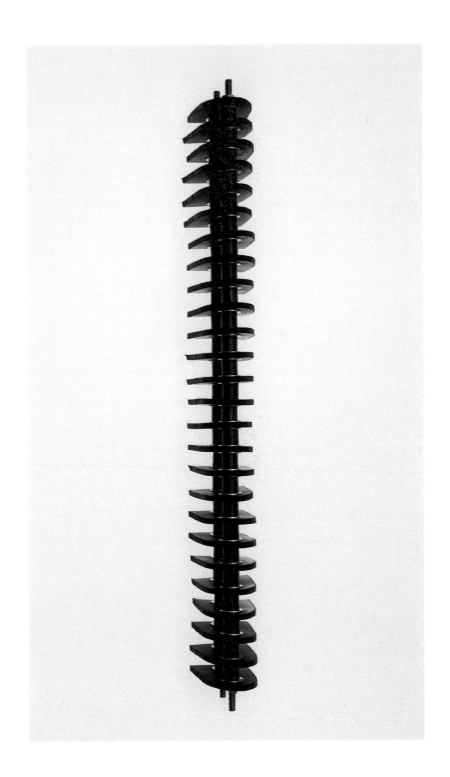

BÅRD BREIVIK
Untitled VII. 1982
a) Black rubber
 83 × 14 × 7¹⁄₁₆″ (210 × 36 × 18 cm.)
b) Vulcalan rubber
 83 × 14 × 7¹⁄₁₆″ (210 × 36 × 18 cm.)
Photo: Carl Henrik Tillberg

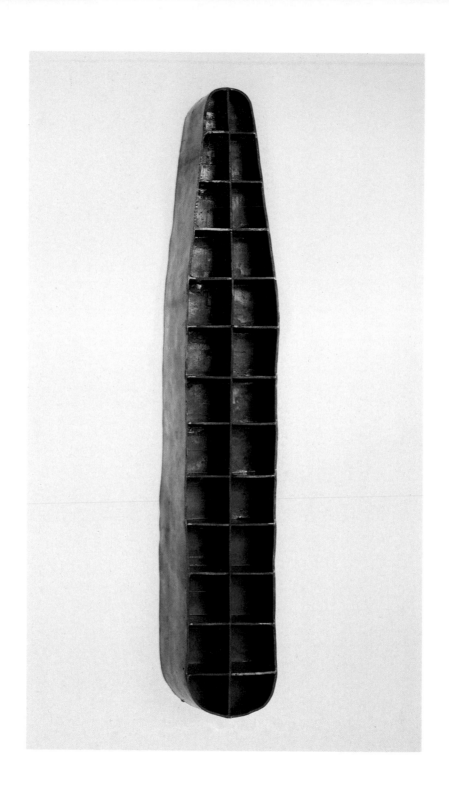

BÅRD BREIVIK
Untitled VIII. 1982
Lead
83 × 14 × 7⅛″ (210 × 36 × 20 cm.)
Photo: Carl Henrik Tillberg

BÅRD BREIVIK
Untitled IX. 1982
Mixed media
83 × 14 × 8¼″ (210 × 36 × 21 cm.)
Photo: Carl Henrik Tillberg

41

Lars Englund

Born 1933 in Stockholm. Lives in Stockholm.
Studies with Vilhelm Bjerke-Petersen, Stockholm
1950−51 and with Fernand Léger, Paris 1952.

*For their generous help and support Lars Englund wishes to
express his gratitude to:*
Billy Klüver, New York, Dr. Byron Pipes and Dr. William
Dick at the Center for Composite Materials, University of
Delaware, SAAB-SCANIA, Linköping, Sweden, Hercules
Inc., Wilmington, Del. and to Ciba-Geigy, Gothenburg,
Sweden.

ONE MAN SHOWS (selection)
Lilla Paviljongen, Stockholm 1953
Galerie Burén, Stockholm 1965, 1967, 1974
Galeria Foksal, Warsaw 1967, 1971, 1976
Galerie Ileana Sonnabend, Paris 1968
Galerie Astley, Köping, Sweden 1974
Galerie Aronowitsch, Stockholm 1975, 1978, 1980
P.S.1, New York 1980
Centre Culturel Suédois, Paris 1981
Galleriet, Lund, Sweden 1981

GROUP SHOWS (selection)
Eleven Swedish Artists, Arts Council, London 1963
Art in Concrete, Moderna Museet, Stockholm 1964
Paris Biennale 1965
Amos Anderson Art Museum, Helsinki 1965
Inner and Outer Space, Moderna Museet, Stockholm 1966
Six Painters from Sweden, Arts Council, London 1966
Collection S, Moderna Museet, Stockholm 1967
Structures gonflables, Musée d'Art Moderne de la Ville de Paris
 1968
Six Swedish Artists, Camden Art Centre, London 1969
Licht−Objekt−Bewegung−Raum, Nürnberg, Stuttgart;
 Louisiana, Humlebæk, Denmark; Gothenburg, Sweden
 1970

Svenskt Alternativ, Moderna Museet, Stockholm 1970
ROSC' '71, Dublin 1971
Alternative Suédoise, Musée d'Art Moderne de la Ville de Paris
 1971
Nordic Art, Nordic Art Society, Reykjavik 1972
International Events '72−76, Venice Biennale 1976
ROSC' '77, Dublin 1977
Nordic Pavilion, Venice Biennale 1978
The nordic contribution to the Venice Biennale 1978, also
 shown at Moderna Museet, Stockholm 1979, Århus Art
 Museum, Denmark, Nordic Arts Centre, Helsinki, Gallery
 F 15, Moss, Norway
Middelheimpark, Antwerp 1979
Skulptur im 20 Jahrhundert, Wenkenpark, Basel 1980
Sculpture Now, Galerie Nordenhake, Malmö, Sweden 1981
Moderna Museet Visits Palais des Beaux-Arts, Brussels 1981
Englund−Kirschenbaum−Ohlin, Moderna Museet, Stockholm
 1982

REPRESENTED
Musée National d'Art Moderne, Centre Georges Pompidou,
 Paris
Museum Sztuki w Lodzi, Lodz, Poland
Moderna Museet, Stockholm
Nationalmuseum, Stockholm

LARS ENGLUND
Montage for Animated Film. 1960–63
Oil lacquer on foil
66⅛ × 39⅜″ (168 × 100 cm.)
Collection William Aronowitsch, Stockholm
Photo: Jan Jansson

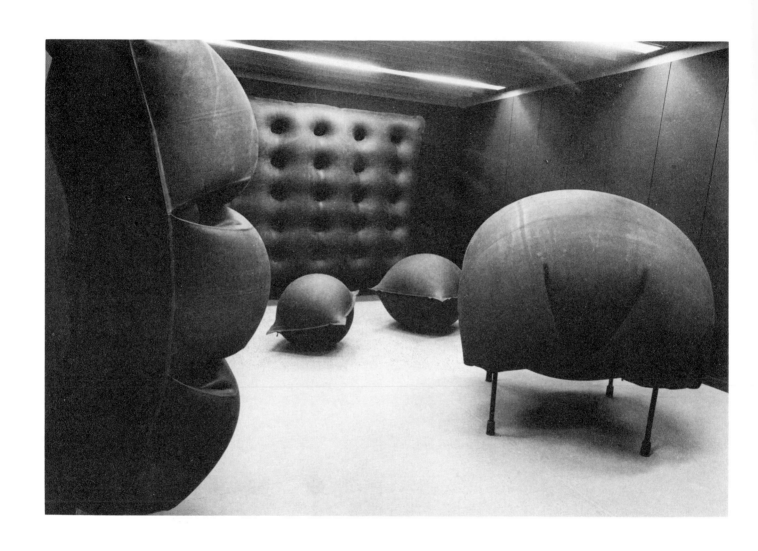

LARS ENGLUND
Volumes. 1964—66
Rubber
Exhibition at Galerie Foksal PSP Warsaw 1966
Photo: Eustachy Kossakowski

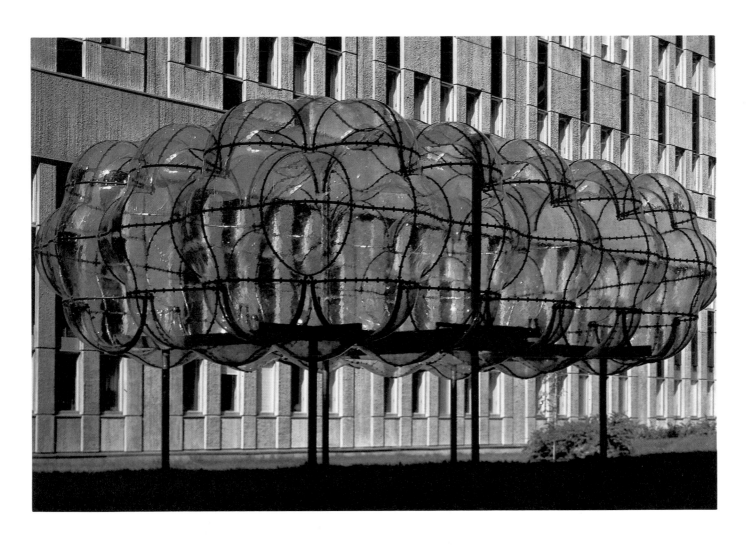

LARS ENGLUND
Building. 1968–73
Polycarbonate, steel and rubber
315 × 212⅝ × 126″ (800 × 540 × 320 cm.)
Photo: Ivo Englund

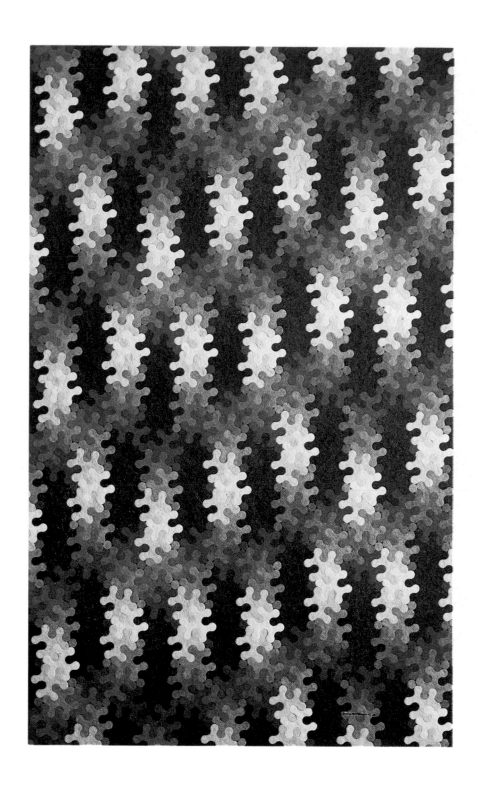

LARS ENGLUND
Pars pro toto. 1975
Felt
66⅛ × 41″ (168 × 104 cm.)
Photo: Jan Almerén

46

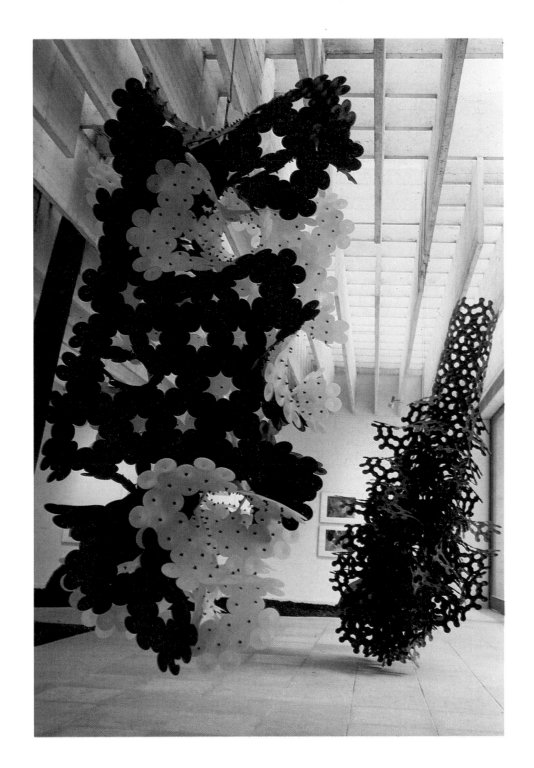

LARS ENGLUND
Pars pro toto
Venice Biennale 1978
Delrin
118⅛ × 51³⁄₁₆ × 51³⁄₁₆″ (300 × 130 × 130 cm.)
164⅜ × 70⅞ × 70⅞″ (420 × 180 × 180 cm.)
Photo: Ivo Englund

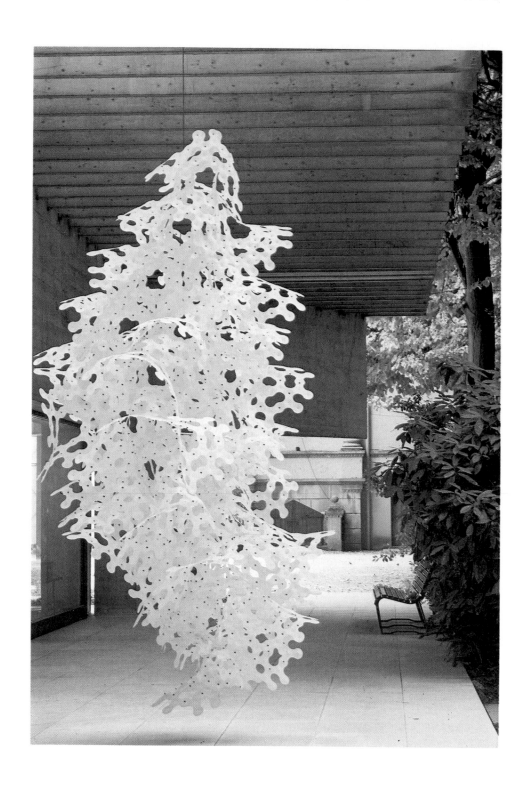

LARS ENGLUND
Pars pro toto
Venice Biennale 1978
Delrin
157½ × 78¾ × 78¾″ (400 × 200 × 200 cm.)
Photo: Ivo Englund

LARS ENGLUND
Pars pro toto. 1979
Polycarbonate
37⅜ × 17¹¹⁄₁₆″ (95 × 45 cm.)
Collection William Aronowitsch, Stockholm

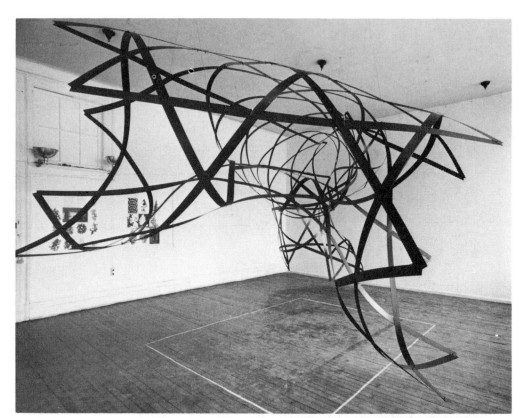

LARS ENGLUND
Relative
P.S.1, New York 1980
Graphitefibre
137¹³⁄₁₆ × 315 × 137¹³⁄₁₆″
(350 × 800 × 350 cm.)
Photo: Yvonne Möller

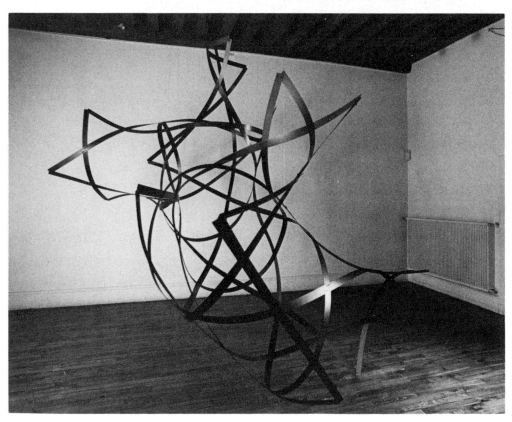

LARS ENGLUND
Relative
Centre Culturel Suédoise, Paris 1981
Graphitefibre
157½ × 118⅛″ (400 × 300 cm.)
Photo: Eustachy Kossakowski

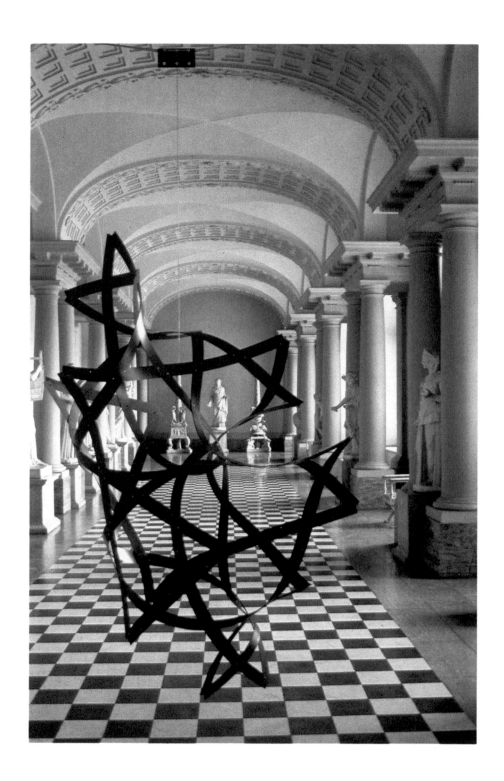

LARS ENGLUND
Relative
Gustav III:s Antikmuseum, Royal Palace, Stockholm 1982
Model for sculpture for Guggenheim, scale 1:5
Graphitefibre
78¾ × 47¼″ (200 × 120 cm.)
Photo: Yvonne Möller

Hreinn Fridfinnsson

Born 1943 in Dölum, Iceland. Lives in Amsterdam.
Studies at College of Art and Crafts in Reykjavik
1958–60. Co-founder of artists' group SÚM and
Gallery Súm.

ONE MAN SHOWS (selection)
Gallery 845, Amsterdam 1971
In-Out Center, Amsterdam 1972
Gallery Súm, Reykjavik 1974
Gallery Gaëtan, Geneva 1976
Gallery Sudurgata 7, Reykjavik 1977
Seriaal, Amsterdam 1977
Gallery Elsa von Honolulu, Ghent, Belgium 1977
Gallery Helen van der Meij, Amsterdam 1979
Gallery Bama, Paris 1979

GROUP SHOWS (selection)
Súm I, Asmundarsalur, Reykjavik 1965
Súm III, Gallery Súm, Reykjavik 1969
Súm IV, Gallery Súm, Reykjavik 1971
Súm Festival, Reykjavik 1972
Paris Biennale 1973
H$_2$O, Nikolai Church, Copenhagen 1974
T'Hoogt, Utrecht 1974

Frans Hals Museum, Haarlem 1974
Art Museum, Lucerne 1975
Gallery Waalkens, Finsterwolde, The Netherlands 1975
Ça va? ça va, Musée National d'Art Moderne, Centre Georges
 Pompidou, Paris 1977.
Eleven Contemporary Icelandic Artists, Malmö Art Hall,
 Malmö, Sweden 1978
Personal Worlds, Stedelijk Museum, Amsterdam 1979

REPRESENTED
National Museum, Reykjavik
The Living Art Museum, Reykjavik
Municipal Collection, Reykjavik
The Workers' Union's Museum, Reykjavik
Moderna Museet, Stockholm
Musée National d'Art Moderne, Centre Georges Pompidou,
 Paris
Netherlands Government Collection
Municipal Collection, Amsterdam

The Origin

In the book *Islenskur Adall* (*Icelandic Aristocracy*) by the author Thorber-gur Thordarson, which was first published in 1938, there is a little story of a man called Solon Gudmundsson—an "aristocrat." He lived in a fishing village in the North West of Iceland where he had a small house. He was a very hospitable man and his house served as a private hotel for many other "aristocrats" who did not have a fixed address or position in society, but chose freedom and mobility to be more fit for the study and enjoyment of life. Solon Gudmundsson was a man of many talents. Early in life he became familiar and efficient with most jobs on the sea and on land. For example he was a good carpenter. He composed a very special and personal kind of poetry which he himself called "light jokes." He also made several interesting objects of no practical purpose except to help develop his and other people's consciousness. It is likely that he was considered mad by most people, but his madness was tolerated because he did not bother anybody, could look after himself and even help others, and because he and his acts were a welcome source of conversation in the village. When Solon Gudmundsson was already an old man, he sold his house and started build-ing a new one, using mostly wood and corrugated iron, a widely used building material in Iceland.

The following is a shortened and freely translated extract from the book *Islenskur Adall*:

He started building the house in the following manner: first he made a wooden construction in an ordinary way, then fixed corrugated iron sheets on the inside of the wooden frame and started living in the building at this stage. The building process was to continue depending on the economic situation and other circumstantial conditions. Solon wanted to build this house completely in the reverse order of traditional architecture, that is to say putting the corrugated iron on the inside and finishing with wallpaper on the outside. When Solon was asked why he planned to build the house in this way, he answered with a faint smile: "Wallpaper is to please the eye, love, so it is reasonable to have it on the outside where more people can enjoy it." But Solon did not get very far with his project because some very concerned friends managed with much difficulty to persuade him to retire to an old people's home. There he was well cared for until he died on the 18th of October, 1931.

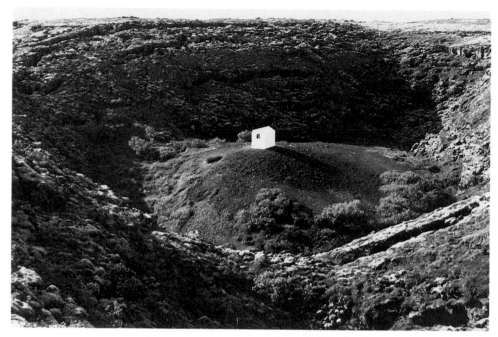

HREINN FRIDFINNSSON
Houseproject. 1974
One of sixteen color photographs
each 8 × 11½" (20 × 29 cm.)
Collection Moderna Museet, Stockholm

The House

In the summer of 1974, a small house was built in the same fashion as Solon Gudmundsson intended to do about half a century ago, that is to say an inside-out house. It was completed on the 21st of July. It is situated in an unpopulated area of Iceland, in a place from which no other man-made objects can be seen.

The existence of this house means that "outside" has shrunk to the size of a closed space formed by the walls and the roof of the house. The rest has become "inside."

This house harbors the whole world except itself.

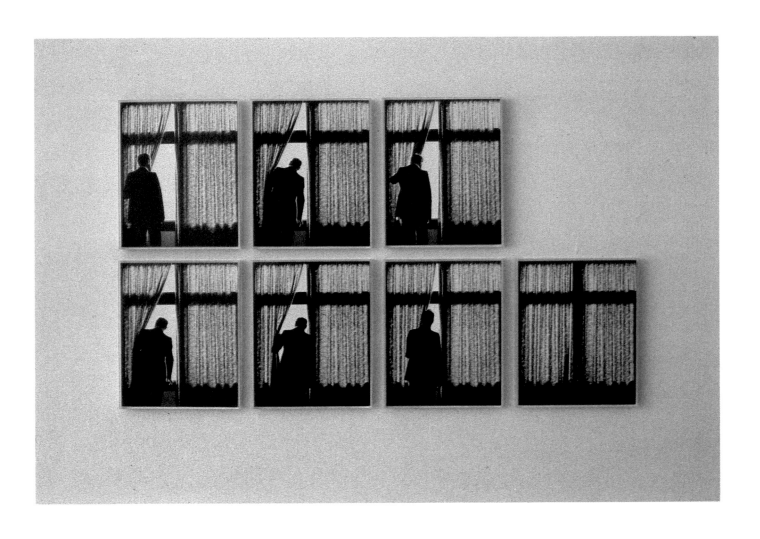

HREINN FRIDFINNSSON
Seven Times. 1978–79
Photograph
31½ × 47¼″ (80 × 120 cm.)
State-Owned Art Collections Department, The Netherlands

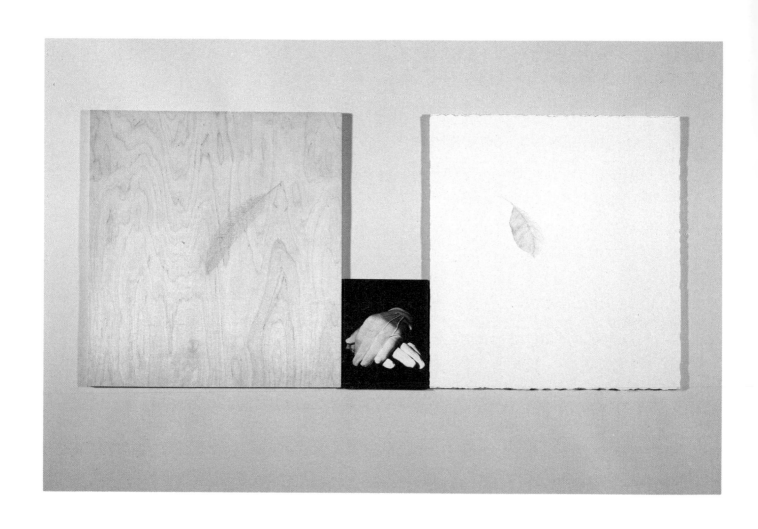

HREINN FRIDFINNSSON
A While. 1978–79
Photograph, watercolor and woodcarving, three panels,
total 23⅝ × 47¼″ (60 × 120 cm.)

56

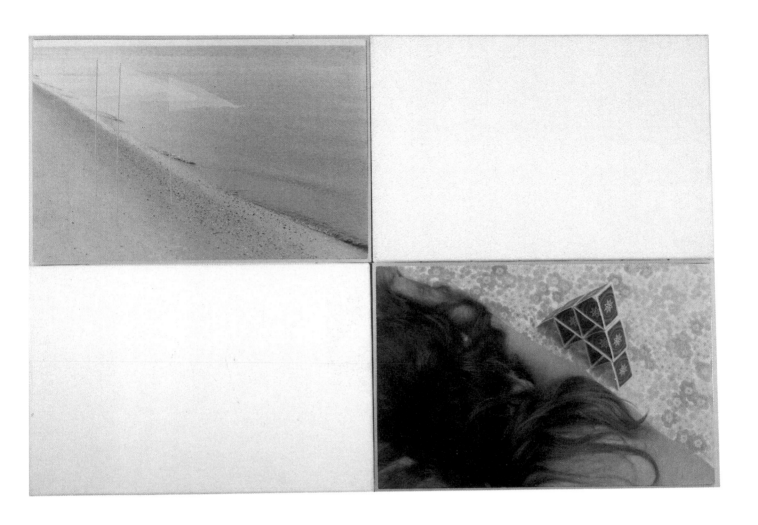

HREINN FRIDFINNSSON
Couplet. 1978–79
Photograph, watercolor and woodcarving, four panels,
total 39⅜ × 47¼″ (100 × 120 cm.)

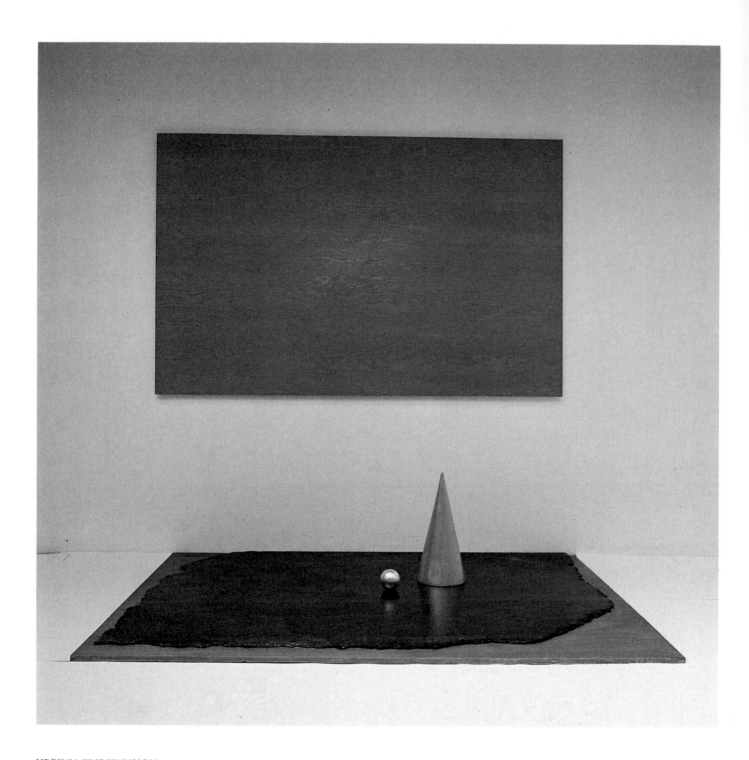

HREINN FRIDFINNSSON
The Hour. 1980
Floor piece, woodcarving,
49¼ × 74¹³⁄₁₆″ (125 × 190 cm.)
Wall piece, marble, wood, gold and silver,
53³⁄₁₆ × 74¹³⁄₁₆″ (135 × 190 cm.)
Collection the City of Amsterdam
Photo: Bob van Danzig

58

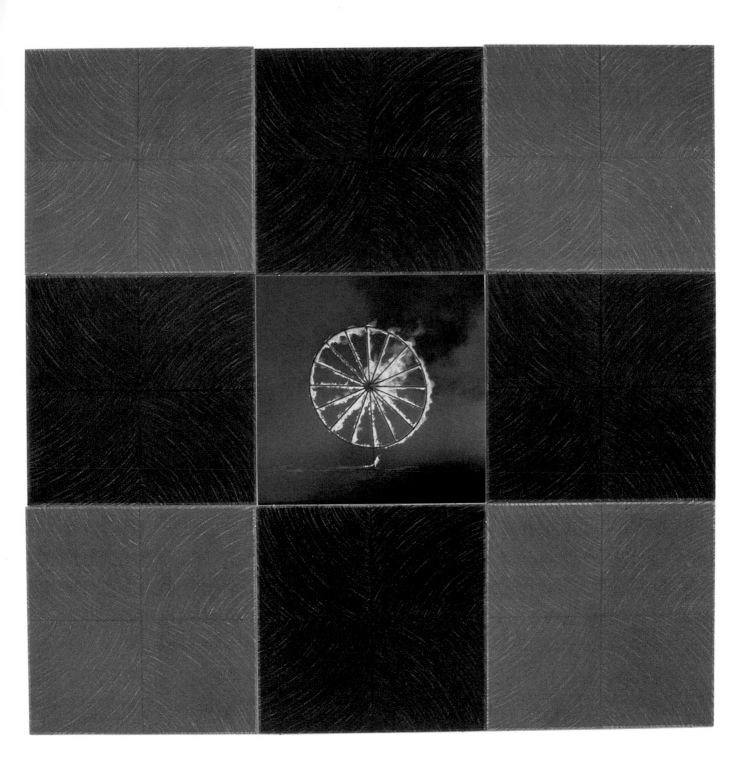

HREINN FRIDFINNSSON
Territory. 1982
Photograph and chalk on paper
70⅞ × 70⅞″ (150 × 150 cm.)
Collection the City of Amsterdam

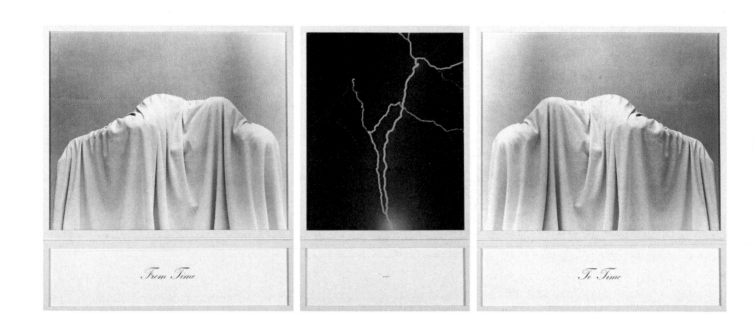

HREINN FRIDFINNSSON
From Time To Time. 1978–79
Photograph and text, six panels,
total 27⁹⁄₁₆ × 63″ (70 × 160 cm.)

HREINN FRIDFINNSSON
Sketch for **Serenata.** 1982
Photograph, glass and wood
63 × 102⅜″ (160 × 260 cm.)

Sigurdur Gudmundsson

Born 1942 in Reykjavik, Iceland. Lives in Amsterdam.
Studies at College of Art and Crafts in Reykjavik
1960—63, Academie 63 in Haarlem 1963—64 and
Ateliers 63, Haarlem 1970—71.
Co-founder of artists' group SÚM and Gallery SÚM.

ONE MAN SHOWS (selection)
Gallery Súm, Reykjavik 1969
Gallery Baldrich, Mönchengladbach, West Germany 1971
Gallery 845, Amsterdam 1972
In-Out Center, Amsterdam 1972
Art Museum, Lucerne 1975
Seriaal, Amsterdam 1976
Gallery Súm, Reykjavik 1977
Gallery Helen van der Meij, Amsterdam 1979
Stedelijk Museum, Amsterdam 1980
Gallery Helen van der Meij, Amsterdam 1981
Kruithuis, Den Bosch, The Netherlands 1982

GROUP SHOWS (selection)
Súm III, Gallery Súm, Reykjavik 1969
Nordic Youth Biennale, Artists' House, Oslo 1970
Súm IV, Museum Fodor, Amsterdam 1971
The Reykjavik Art Festival, Reykjavik 1972
Paris Biennale 1973
H₂O, Nikolai Church, Copenhagen, 1974
Frans Hals Museum, Haarlem 1974
Gallery Waalkens, Finsterwolde, The Netherlands 1975
International Events '72—76, Venice Biennale 1976
Ça va? ça va, Musée National d'Art Moderne, Centre Georges
 Pompidou, Paris 1977
Nordic Pavilion, Venice Biennale 1978
The Nordic contribution to the Venice Biennale 1978, also

shown at Moderna Museet, Stockholm 1979, Århus Art
 Museum, Denmark, Nordic Arts Centre, Helsinki, Gallery
 F 15, Moss, Norway
Eleven Contemporary Icelandic Artists, Malmö Art Hall,
 Malmö, Sweden 1978
Personal Worlds, Stedelijk Museum, Amsterdam 1979
To Do with Nature, Pulchri Studio, The Hague 1979
The Sydney Biennale 1979
Five Northerners, Trollhättan, Borås and Gothenburg Art
 Museums, Sweden 1980
Aktuelle Kunst aus den Niederlanden, Landespavillon, Stutt-
 gart 1980
Pier and Ocean, Hayward Gallery, London 1980
Contemporary Art from The Netherlands, Museum of Con-
 temporary Art, Chicago 1982
'60—'80, Stedelijk Museum, Amsterdam 1982

REPRESENTED
The Living Art Museum, Reykjavik
Municipal Collection, Reykjavik
Stedelijk Museum, Amsterdam
Rijksmuseum Krøller-Müller, Otterlo, The Netherlands
Musée National d'Art Moderne, Centre Georges Pompidou,
 Paris
Moderna Museet, Stockholm
Netherlands Government Collection
Municipal Collection, Amsterdam

The quality of any art depends on the relationship between the artist and his work.

A good work of art will be an imprint of his soul. Only by loving and admiring such works is one able to journey in the landscape of art. For years, I lived in that landscape.

Nowadays my impulses to make art are drawn, increasingly, from another landscape, from that of the ebb and flow, sun and rain, day and night, love and grief.

But I am, I must admit, frequently homesick for the beautiful experiences I enjoyed during my journey through the landscape of art.

SIGURDUR GUDMUNDSSON
Rendez-vous. 1976
Photograph and text on cardboard
28⁹/₁₆ × 35⁷/₈″ (72.5 × 91 cm.)
Collection Moderna Museet, Stockholm

SIGURDUR GUDMUNDSSON
Molecule. 1979
Color photograph and text
51³⁄₁₆ × 59¹⁄₁₆″ (130 × 150 cm.)
Collection Rijksmuseum Kröller-Müller, Otterlo, The Netherlands

SIGURDUR GUDMUNDSSON
The Katanes Beast. 1981
Drawing
47¼ × 74⅜″ (120 × 189 cm.)
Photo: Wiebe Schipmölder

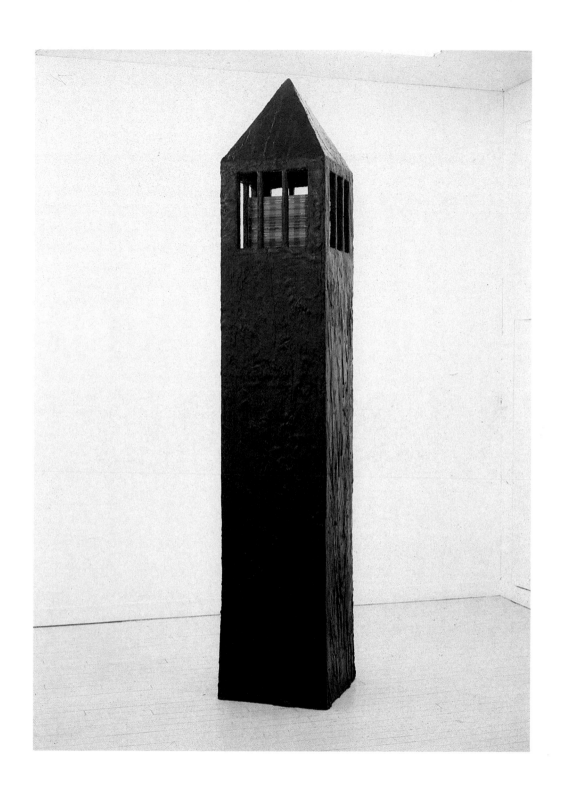

SIGURDUR GUDMUNDSSON
Untitled Black Sculpture. 1981
Tar on wood and glass
137¹³⁄₁₆ × 27⁹⁄₁₆ × 27⁹⁄₁₆″ (350 × 70 × 70 cm.)
Photo: Pieter Mol

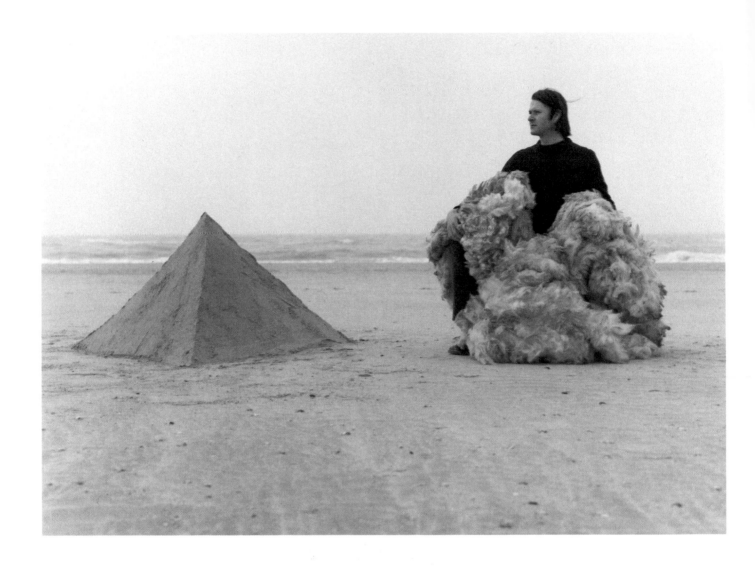

SIGURDUR GUDMUNDSSON
Mathematics. 1979
Color photograph and text
45¼ × 50⅜″ (115 × 128 cm.)
Collection Rijksmuseum Kröller-Müller, Otterlo, The Netherlands

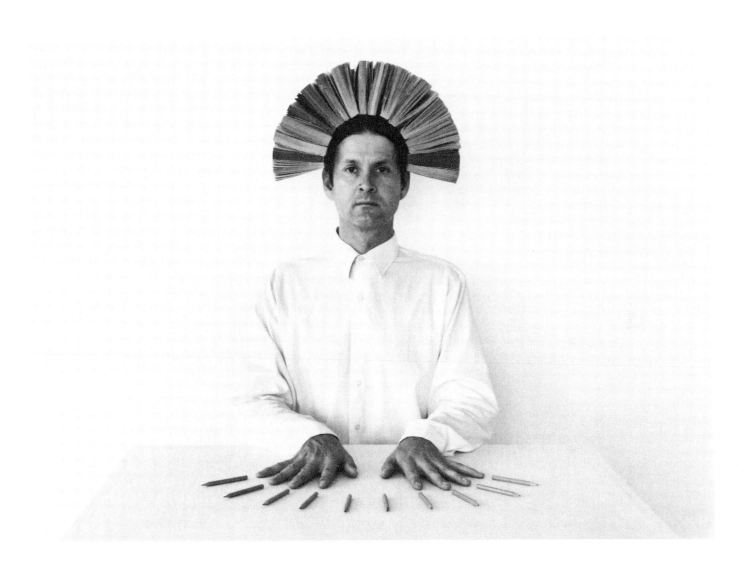

SIGURDUR GUDMUNDSSON
Historiana. 1981
Photopraph and text
40⁹/₁₆ × 45¹¹/₁₆″ (103 × 116 cm.)

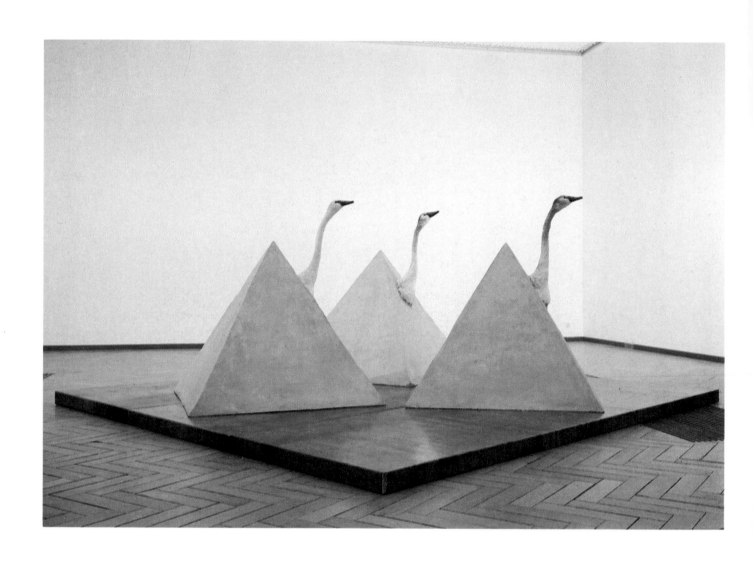

SIGURDUR GUDMUNDSSON
The Great Poem. 1981
Concrete, swans and steel
137¹³⁄₁₆ × 137¹³⁄₁₆ × 59¹⁄₁₆″ (350 × 350 × 150 cm.)
Collection Stedelijk Museum, Amsterdam
Photo: Tom Haartsen

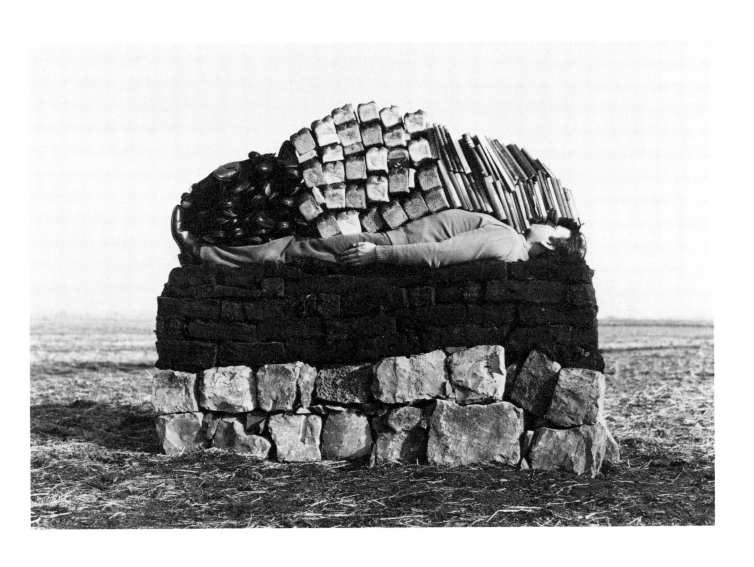

SIGURDUR GUDMUNDSSON
Mountain. 1980–82
Photograph and text
50⅜ × 53¹⁵⁄₁₆″ (128 × 137 cm.)

Per Kirkeby

Born 1938 in Copenhagen. Lives in Copenhagen.
Studies at University of Copenhagen 1957–64 (natural
sciences). Several geological expeditions. Professor at
State Academy of Fine Arts of Karlsruhe since 1978.

ONE MAN SHOWS (selection)
Main Library, Copenhagen 1964
Den Fries Udstillingsbygning, Copenhagen 1965
Euclid's Room, Gallery Jensen, Copenhagen 1965
Gallery 101, Copenhagen 1967
Jysk Art Gallery, Copenhagen 1969
Fyns Stiftsmuseum, Odense, Denmark 1968
Jysk Art Gallery, Copenhagen 1969
Karlsons Klister I, Daner Gallery, Copenhagen 1972
Gentofte Art Library, Copenhagen 1972
Gallery S:t Petri, Lund, Sweden 1973
Haderslev Museum, Haderslev, Denmark 1974
Galerie Michael Werner, Cologne 1974
Karlsons Klister II, Daner Gallery, Copenhagen 1975
Retrospective exhibition–drawings and graphic works, Royal
 Fine Arts Museum, Copenhagen 1975
Århus Kunstbygning, Århus, Denmark 1975
Gallery Cheap Thrills, Helsinki 1976
Ribe Museum, Ribe, Denmark 1976
Museum Folkwang, Essen 1977
Galerie Michael Werner, Cologne 1978
Kunstraum München, Munich 1978
Art Hall, Bern 1979
Galerie Fred Jahn, Munich 1980
Gallery Helen van der Meij, Amsterdam 1980
Galerie Michael Werner, Cologne 1980
Galerie Michael Werner, Cologne 1982
Painters' Gallery, Helsinki 1982

GROUP SHOWS (selection)
The Experimental Art School, Gallery Admiralgade 20,
 Copenhagen 1962
Young Danish Art, Den Fries Udstillingsbygning, Copenhagen
 1965
Artists' Autumn Exhibition, Copenhagen 1966
Nordic Youth Biennale, Louisiana Museum, Humlebæk, Den-
 mark 1966
Tabernacle, Louisiana Museum, Humlebæk, Denmark 1970
International Events '72–76, Venice Biennale 1976
Arme und Beine, Art Museum, Lucerne 1976
Arms and Legs, Willumsens Museum, Frederikssund, Den-
 mark 1978
Venice Biennale 1980

Après le classicisme, Musée d'Art Saint-Etienne, Saint-Etienne,
 France 1980
A New Spirit in Painting, Royal Academy of Arts, London
 1980
Der Hund stösst im Laufe der Woche zu mir, Moderna Museet,
 Stockholm 1981
Peinture en Allemagne, Palais des Beaux-Arts, Brussels 1981
Studio Marconi, Milan 1982
Documenta, Kassel 1982

FILMS (selection)
Stevns Klint og Møns Klint, Danmark, 1969. TV production,
 b/w, 16 mm, 40 min. Camera: Thor Adamsen. Music: Hen-
 ning Christiansen
Grønlandsfilmen I, 1969. Color, 8 mm, 30 min. Music: Hen-
 ning Christiansen
Og myndighederne sagde stop, 1972. Feature film from Green-
 land, color, 16 mm, 90 min. Camera: Teit Jørgensen. Sound:
 Peter Sakse. Cutting: Grete Møldrup. Music: Jens Hendrik-
 sen. Production: Per Mannstædt/SFC and DR
Normannerne, 1975. Feature film, color, 35 mm, 90 min. In
 collaboration with Poul Gernes. Camera: Teit Jørgensen.
 Sound: Jan Juhler. Equipment: Peter Højmark. Costumes:
 Jette Termann. Cutting: Maj Soya. Production: Nina
 Crone/Crone Film.
Asger Jorn, 1977. Color, 16 mm, 60 min. Camera: Teit Jørgen-
 sen. Sound: Jan Juhler. Cutting: Grete Møldrup. Produc-
 tion: Vibeke Windeløv/SFC
Geologi – er det egentlig videnskab?, 1980. Color, 16 mm,
 45 min. Camera: Teit Jørgensen. Cutting: Grete Møldrup.
 Production: Vibeke Windeløv/SFC

SFC = Statens Film Central, Denmark

REPRESENTED
Moderna Museet, Stockholm
Louisiana Museum, Humlebæk, Denmark
Silkeborg Art Museum, Silkeborg, Denmark
Henie-Onstad Art Center, Høvikodden, Norway
National Art Foundation, Copenhagen
Carlsberg Foundation, Copenhagen
Stedelijk Van Abbemuseum, Eindhoven, The Netherlands
Bavarian State Art Galleries, Munich

The trunks

The trunks of big trees. The nethermost stem, from the toes of the roots that bore themselves down into the ground, and a distance up, a distance completely free of branches. A frame, a pillar stump. But both are associations that I derive from my historical interest. But what do they look like, the trunks. I draw them, at times with historical eyes, a consciousness of a history, at other times with a pretence of observation. But the observation also wears historical glasses. There are the molded trees, think of Baldung Grien, Dürer, but already then they too flatten out. When Seghers and Altdorfer set about it, the moss mist seeps upward and lichen and moss steam down. The mood of moisture condenses the trunks flat. The feeling is not molded, the feeling is colors, even in black and white. The large feeling is not able to hold the trunks fast as round pillars. The temple pillars become stage settings against the colored sky. Turner. It is the living brush with color on it. The stylized version is the symbolism, the blank surface designated. I cannot even see that trunks are round when I set out to create the reality with pencil and paper. Faced with the uncertain and dangerous substances which are the surroundings, "the reality," it comes out strokes and tones. Tonalities without molded illusion. And the drawing is the reality. The pictorial art is the reality. Therefore it makes me sick when a picture does not turn out, when it shatters, literally physically sick, for there is no place to be, no reality. It is not there until the picture turns out, then there is peace for a time. Dream, that is the molded trees, those I cannot make into reality, but it is pictures, it is the pictures of the dream. In Prince Valiant, which is dream, the trees are molded, but they are caricatures of the molded trees. They are so big and rugged, so marvelously molded that they have never stood in any painter forest. In most modern comic-strips the tree trunks are merely two strokes. Not the limitation of a symbolistic surface, but hastily jotted markings in a space of mood. The feeling supports the reality. All that outside, that we call trees and all else, is not to be trusted. But it is a substance like color in tubes, to create the reality we live in.

Translated by Susan Hebsgaard

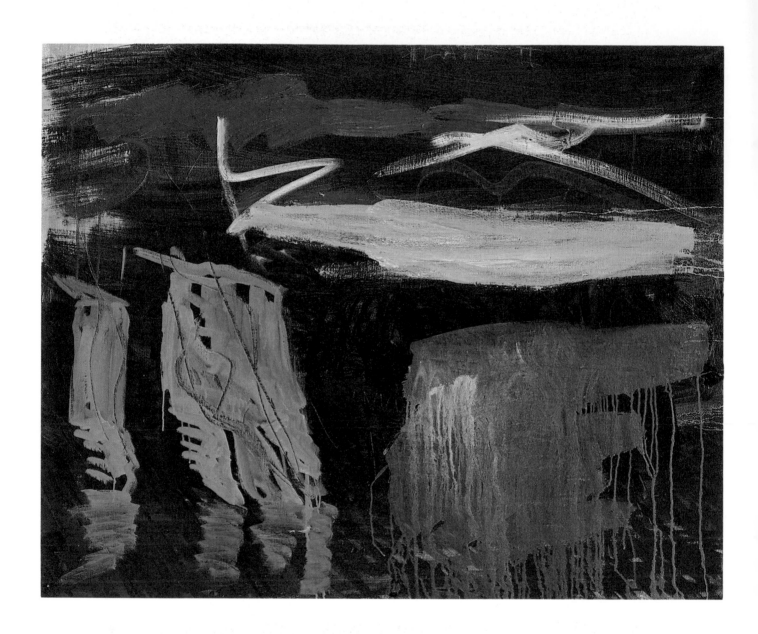

PER KIRKEBY
Plate II. 1981
Oil on canvas
37⅜ × 45¹¹⁄₁₆″ (95 × 116 cm.)
Courtesy Galerie Michael Werner, Cologne

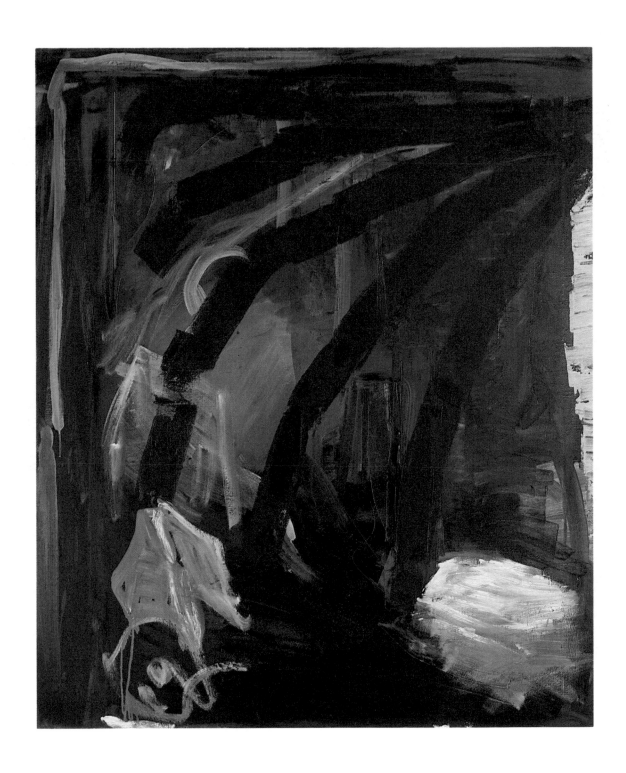

PER KIRKEBY
Untitled (Cave). 1981
Oil on canvas
45¹¹⁄₁₆ × 37⅜″ (116 × 95 cm.)
Courtesy Galerie Michael Werner, Cologne

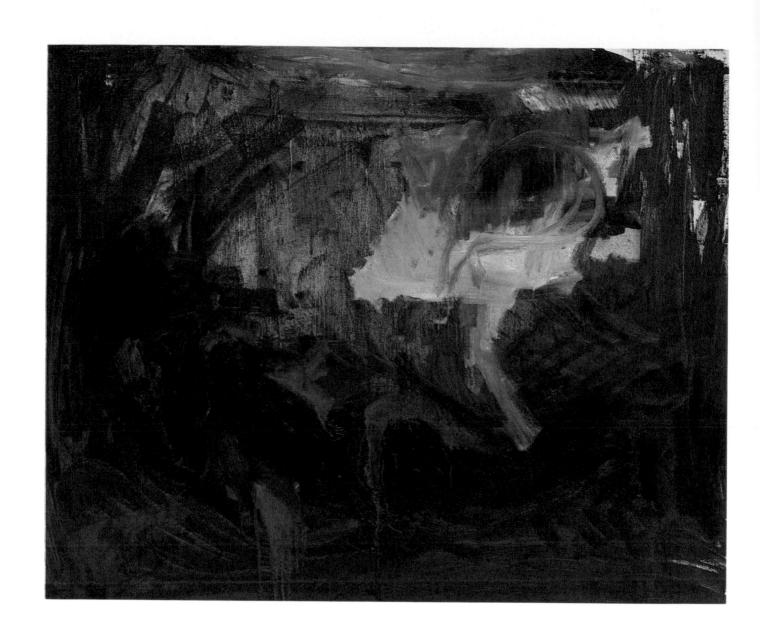

PER KIRKEBY
Untitled. 1981
Oil on canvas
37⅜ × 45¹¹⁄₁₆″ (95 × 116 cm.)
Courtesy Galerie Michael Werner, Cologne

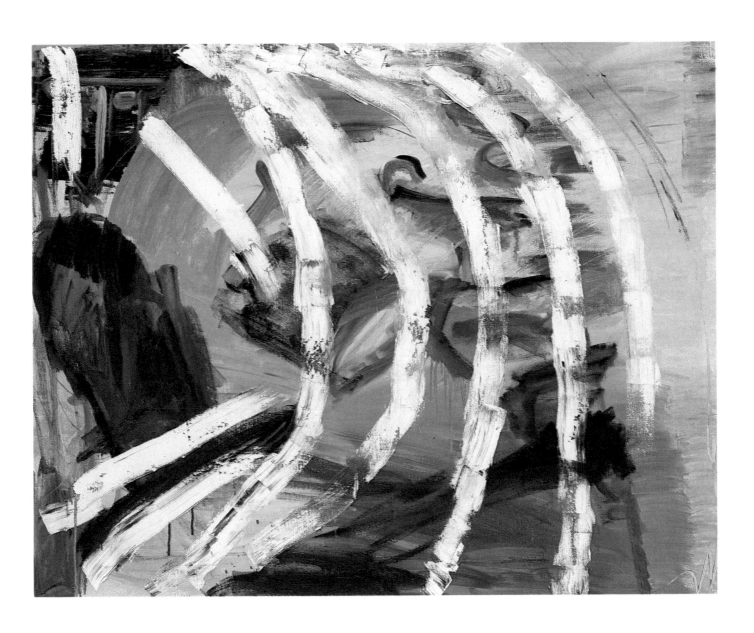

PER KIRKEBY
Untitled (Cave). 1981
Oil on canvas
37⅜ × 45¹¹⁄₁₆″ (95 × 116 cm.)
Courtesy Galerie Hans Neuendorf, Hamburg

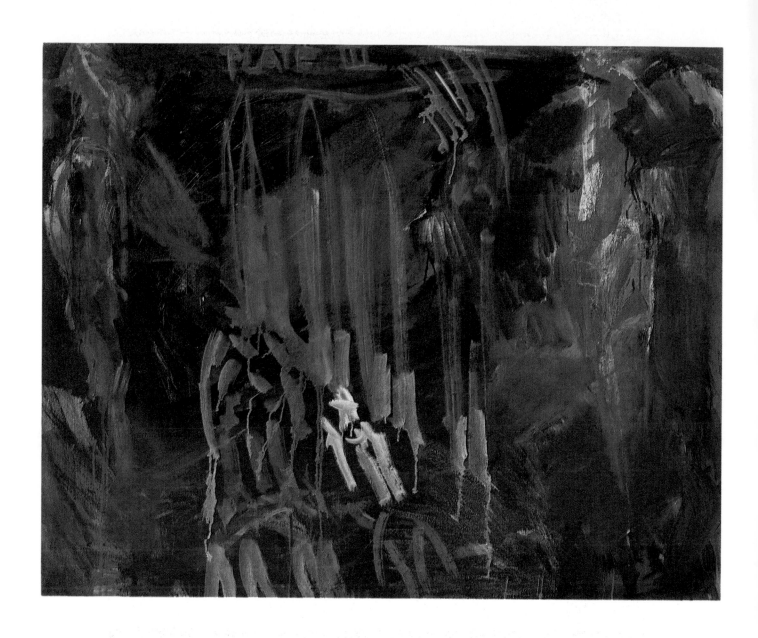

PER KIRKEBY
Plate III. 1981
Oil on canvas
37⅜ × 45¹¹⁄₁₆″ (95 × 116 cm.)
Courtesy Galerie Michael Werner, Cologne

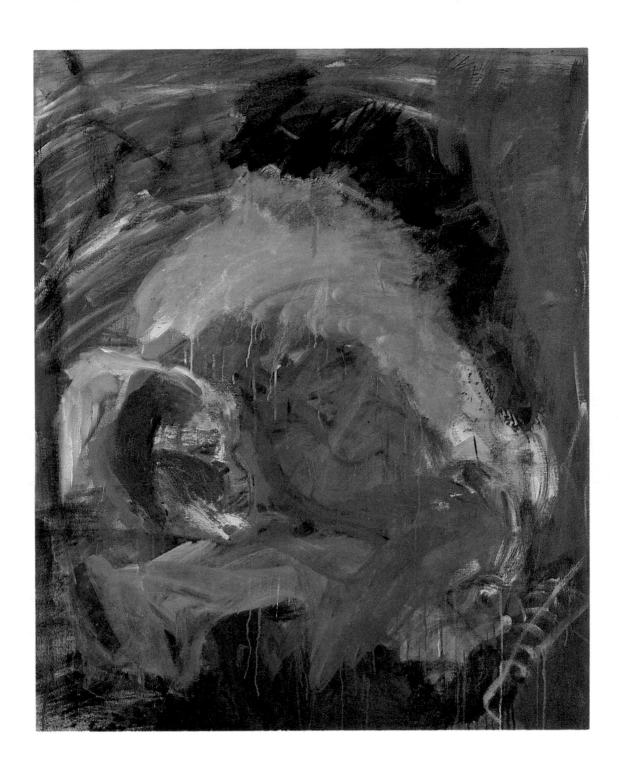

PER KIRKEBY
Untitled. 1981
Oil on canvas
45¹¹/₁₆ × 37³/₈" (116 × 95 cm.)
Courtesy Galerie Hans Neuendorf, Hamburg

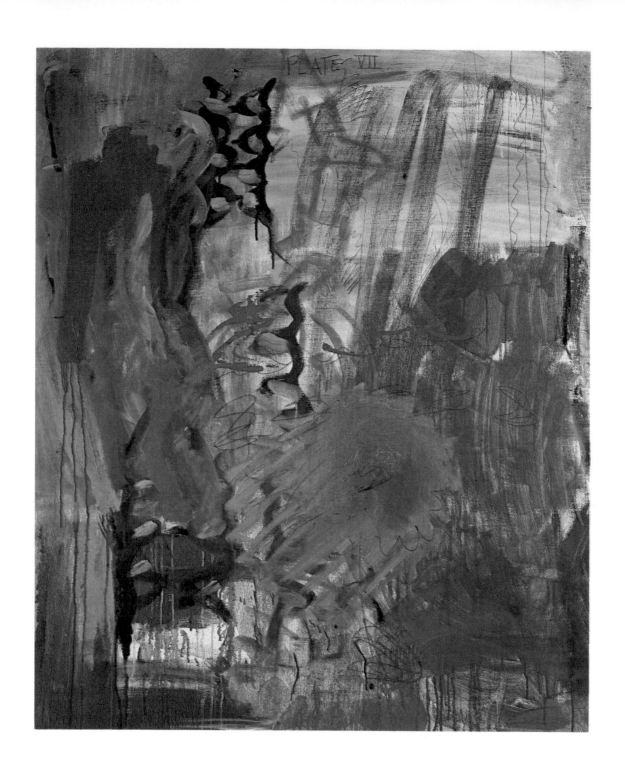

PER KIRKEBY
Plate VII. 1981
Oil on canvas
45$\frac{11}{16}$ × 37$\frac{3}{8}$″ (116 × 95 cm.)
Courtesy Galerie Fred Jahn, Munich

80

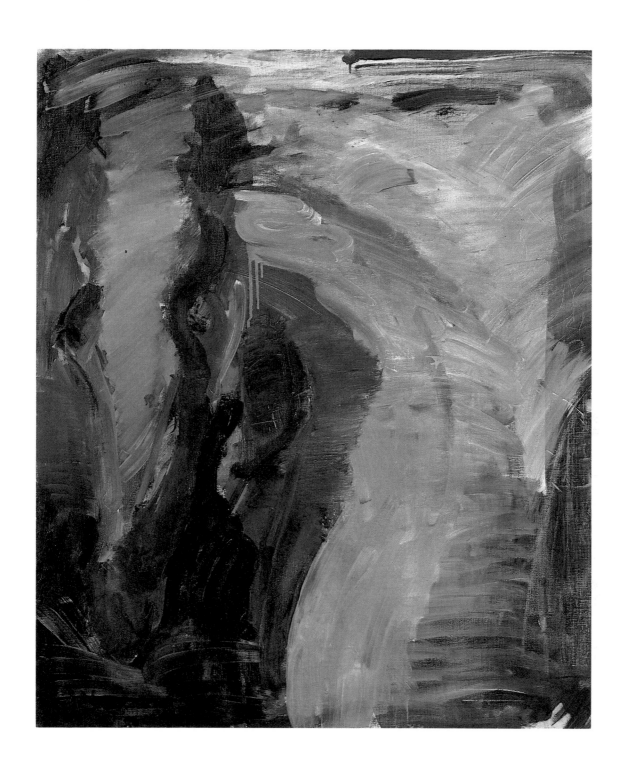

PER KIRKEBY
Untitled (Horse Head). 1981
Oil on canvas
45¹¹/₁₆ × 37³/₈″ (116 × 95 cm.)
Courtesy Galerie Michael Werner, Cologne

Olle Kåks

Born 1941 in Hedemora, Dalecarlia, Sweden. Lives in Stockholm.
Studies at Gerlesborgsskolan, Stockholm 1960−62, and at College of Art in Stockholm 1962−68. Professor at College of Art since 1979.

ONE MAN SHOWS (selection)
Obervatorium, Stockholm 1966
Galerie Aronowitsch, Stockholm 1966
Galerie Burén, Stockholm 1969
Galerie Burén, Stockholm 1972
Galerie Belle, Västerås, Sweden 1974
Norrköping Art Museum, Norrköping, Sweden 1974
Gothenburg Art Hall, Gothenburg, Sweden 1974
Skövde Art Hall, Skövde, Sweden 1974
Södermanlands Museum, Nyköping, Sweden 1974
Kalmar Art Museum, Kalmar, Sweden 1974
Nolhaga Castle, Alingsås, Sweden 1974
Varbergs Museum, Varberg, Sweden 1974
Jönköping County Museum, Jönköping, Sweden 1974
Museum of Dalecarlia, Falun, Sweden 1974
Västerbottens Museum, Umeå, Sweden 1974
Galerie Aronowitsch, Stockholm 1975
Galerie Burén, Stockholm 1975
Galerie Burén, Stockholm 1976
Moderna Museet, Stockholm 1977
Kunsthalle, Basel 1978
Lake Superior, Moderna Museet, Stockholm 1980
Galerie Olson, Stockholm 1980
Painters' Gallery, Helsinki 1981
Louisiana, Humlebæk, Denmark 1982

GROUP SHOWS (selection)
Paris Biennale 1967
17 Young Artists, Royal Academy of Fine Arts, Stockholm 1967
A Touring Art Exhibition, Sundsvalls Museum, Sundsvall−
 Gävle Museum, Gävle − Skånska Art Museum, Lund −
 The Museum, Halmstad, Sweden 1967
Op losse schroven, Stedelijk Museum, Amsterdam 1969
Six Swedish Artists, Camden Art Centre, London 1969
Svenskt Alternativ, Moderna Museet, Stockholm 1970
Alternative Suédoise, Musée d'Art Moderne de la Ville de Paris
 1971
Swedish Alternative, Louisiana, Humlebæk, Denmark, Gallery
 F 15, Moss and Bergen Picture Gallery, Bergen, Norway 1971
New Swedish Images, Amos Anderson Museum, Helsinki 1973
Images du Nord, Dakar, Senegal 1973
International Events '72−76, Venice Biennale 1976
Swedish Art of the 70', Moderna Museet, Stockholm 1979

REPRESENTED
Moderna Museet, Stockholm
Nationalmuseum, Stockholm
Musée National d'Art Moderne, Centre Georges Pompidou,
 Paris
Art Museum, Basel
Bergen Picture Gallery, Bergen, Norway
Ateneum, Helsinki

Gunnar Harding

BETWEEN MUSSEL AND MOON BETWEEN
LIFE AND WOMB BETWEEN GOLD AN
D LEAF BETWEEN FLESH AND BL
OOD BETWEEN MARROW AND E
ARTH BETWEEN FUR AND S
TONE BETWEEN BONE AND
THIGH BETWEEN TAR A
ND FEATHER BETWEE
N BIRTH AND
LIGHT

Poimandres

At once all was unfolded to me, and I beheld an immensity in which all was light, and in that light were gentleness and joy, and I was astonished at what I saw. But soon a sort of darkness emerged, drawing downwards in coiling spirals, dismal and menacing, like unto a serpent. Thereafter the darkness was transformed into a running, wet nature, an indescribably whirling water from which vapor was emitted like the smoke from a fire: and from the water rose a groaning cry, a wild and unimaginable shriek that to me sounded like the voice of fire. At the same instant a holy Word was uttered from the light, and the Word covered the whole of Nature; at which a purified flame rose high above the wetness, up towards the place of glory. The fire was light, lively and eager; and the air, also light, followed the ignited gust, rising with the fire from the earth and water, as if suspended to the fire, while the earth and water remained where they had been, so mixed with each other that they were hard to distinguish. All this was set in constant motion by the breath of the Word, which had withdrawn into the heights, distinguishable only to the ear.

from Corpus Hermeticum'
a gnostic codex written around A.D. 200

OLLE KÅKS
Name Object. 1978
Installation view
Kunsthalle Basel
Photo: Christian Baur

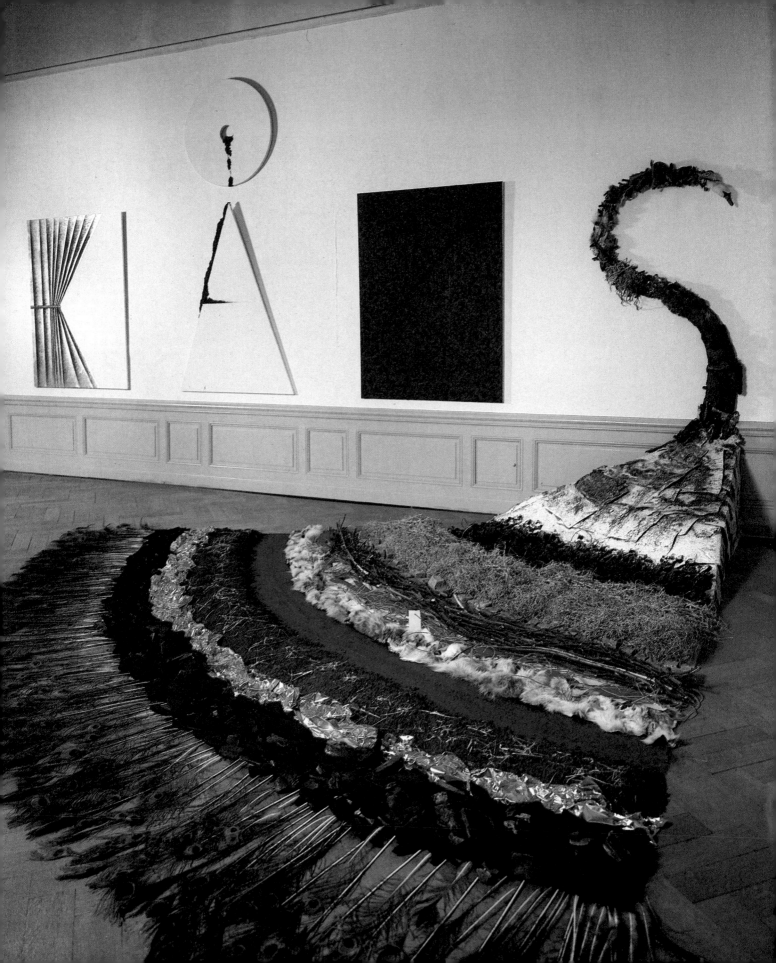

OLLE KÅKS
Uprooted. 1979
Oil on canvas mounted on panel,
variable dimensions, approximately 78¾ × 393¾″ (200 × 1,000 cm.)

86

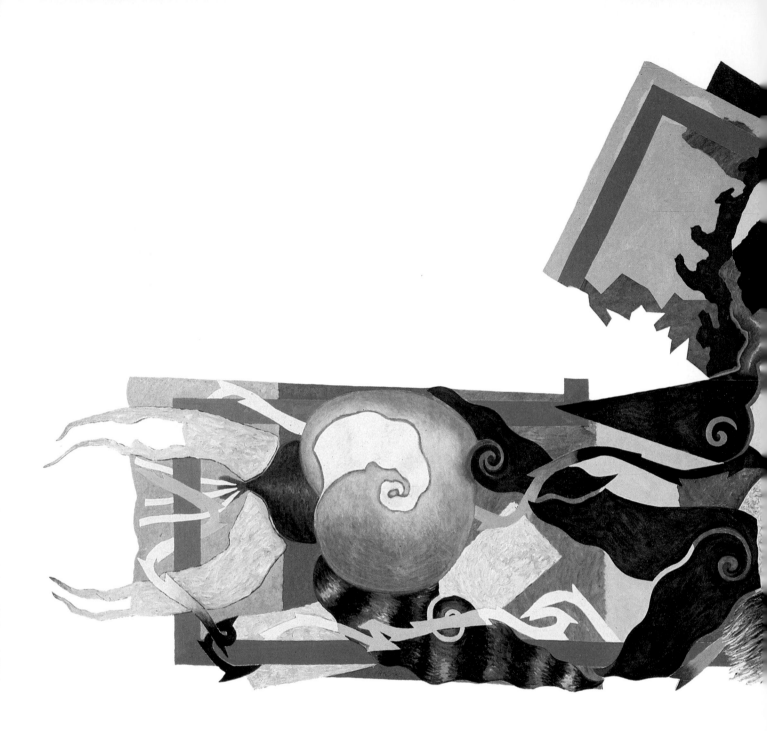

OLLE KÅKS
Coléopter. 1980
Oil on canvas mounted on panel
103⅛ × 236¼″ (262 × 616 cm.)
Musée National d'Art Moderne, Centre Georges Pompidou, Paris

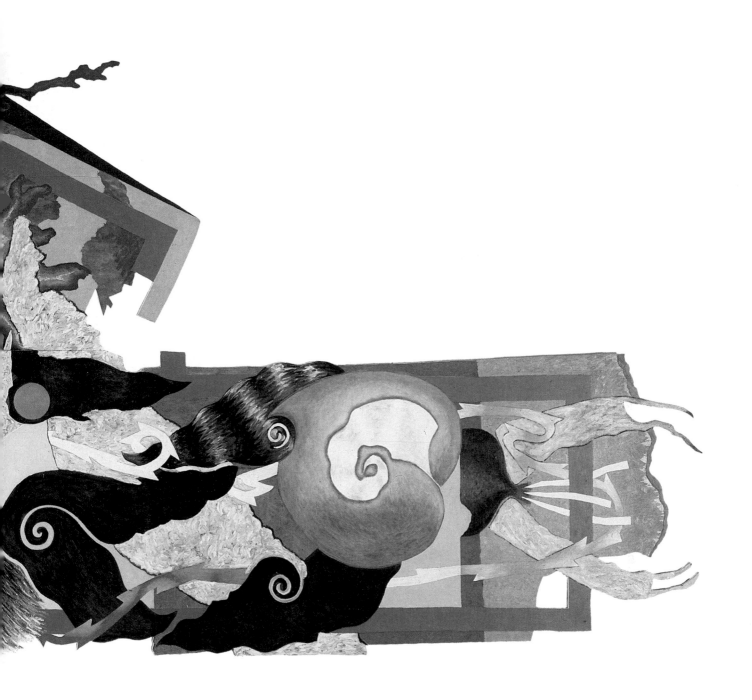

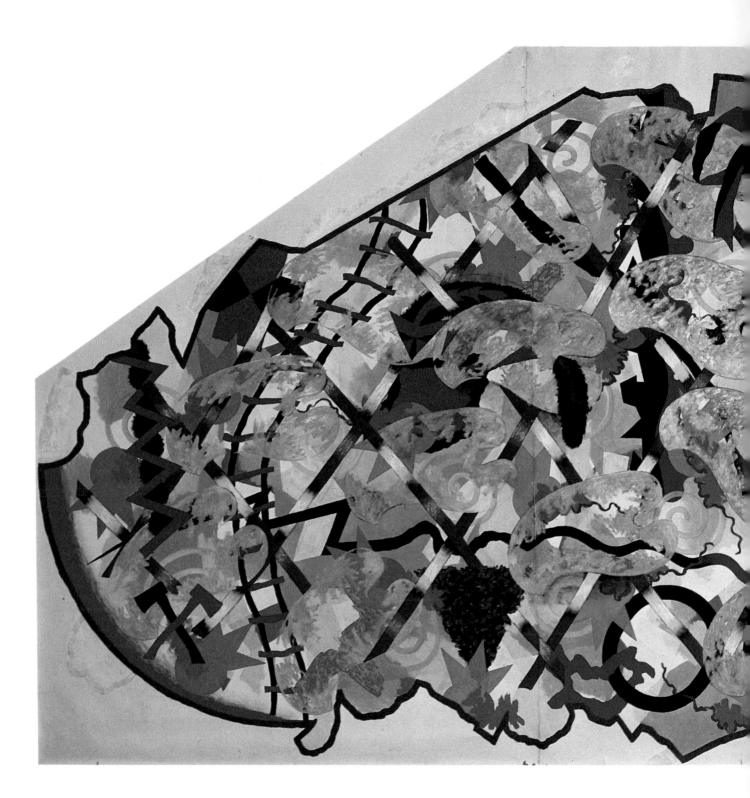

OLLE KÅKS
Market Garden. 1982
Oil on canvas
110¼ × 233⅞″ (280 × 594 cm.)
Photo: Jan Almerén

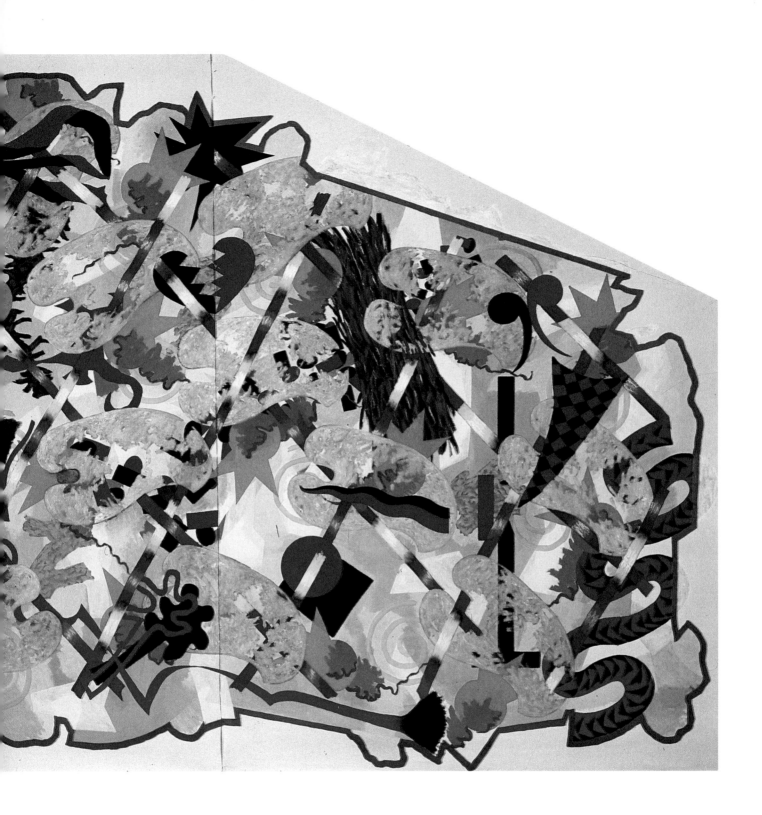

Olli Lyytikäinen

Born 1949 in Heinävesi, Finland. Lives in Helsinki.
Autodidact.
Co-founder of artists' group the Reapers.

Portrait of Olli Lyytikäinen by Kaija Saariaho

ONE MAN SHOWS (selection)
Aus die pathologische Schizzenbücher, Gallery Cheap Thrills,
 Helsinki 1971
From Africa to Eternity, Gallery Cheap Thrills, Helsinki
 1973
Galerie Artek, Helsinki 1975
The Pen, the Paper and the Truth, Gallery Cheap Thrills,
 Helsinki 1976
The Duckburg Art Museum Collection, Galerie Christel,
 Stockholm 1977
Åbo Art Museum, Åbo, Finland 1977
Galerie Artek, Helsinki 1978
Katariinan Galleria, Helsinki 1979
The Fire of the Old Student House, Old Student House,
 Helsinki 1980
Bird Nurse, Galleri Engström, Stockholm 1980
Old Student House, Helsinki 1981
A ~ over, Galleri Engström, Stockholm 1981
Galerie Grafiart, Åbo, Finland 1982
Galerie Artek, Helsinki 1982

GROUP SHOWS (selection)
13 Erimieltä, Kluuvin Galleria, Helsinki 1967
Real Lies, Kluuvin Galleria, Helsinki 1970
The Spider, Katariinan Galleria, Helsinki 1972
The Reapers, Katariinan Galleria, Helsinki 1972
The Berlin Festival, Suomi Center, Berlin 1973

A Head Museum for the Eighties, Gallery Cheap Thrills,
 Helsinki 1974; Moderna Museet, Stockholm; Archive for
 Decorative Art, Lund, Sweden
Kulturmagasinet Vargen, Moderna Museet, Stockholm 1975
International Events '72–76, Venice Biennale 1976
Adhesiva Arketyper–Young Finnish Art, Amos Anderson Art
 Museum, Helsinki 1976
The Drawing Center, New York 1977
7th International Contemporary Art Exhibition, Delhi 1977
Adhesiva Arketyper, Moderna Museet, Stockholm 1977; Nordens Hus, Reykjavik
Finnish Art, Warsaw 1978; Wroclaw; Szczecinek
1. Internationale Jugend Triennale, Kunsthalle Nürnberg
 1979
Five Northerners, Trollhättan, Borås and Gothenburg Art
 Museums, Sweden 1980
The Rules of the Game, Amos Anderson Art Museum, Helsinki 1981
Moderna Museet Visits Palais des Beaux-Arts, Brussels 1982
The Drawing Center, New York 1982
Paris Biennale 1982

REPRESENTED
Moderna Museet, Stockholm
Ateneum, Helsinki
Amos Anderson Art Museum, Helsinki
City of Helsinki

How To Be a Detective When Bunny Plays Piano

Every situation has its own language, its own agents of expression. I can't imagine a situation in which nothing is done—or I can, but I know it to be false.

There is no inventor who invents a new wheel—the most radical are those who understand how the wheel works.

If an artist does not realize that he always has these many-thousand-year-old eyes, two feet, and two hands with five fingers—then the door won't open.

Olli Lyytikäinen

When Axel Gallen-Kallela, the strongman of Finnish Golden Age Art, was only nineteen he painted an early masterpiece, *Boy and Crow*. — A very naturalistic scene, showing a young lad, half turned away, looking at a crow picking in the right corner of the composition. Shortly afterwards the artist painted another equally poignant picture, *Old Woman and Cat*. The ugly hag is turned towards us, halfway, looking at the cat in the lower right corner.

These are straightforward images, very Finnish, but also archaic, mirroring deep levels of the mind. The idiom and way of painting is the same in both but the psychic content is reversed. They contain the nucleus of the artist's vision, later to develop into a huge body of dramatic work, including the powerful illustrations to the *Kalevala*, Finland's national epic, a source-book for the Finnish mind.

But the sparks that triggered off Gallen-Kallela's vision are found already in these two images. The first image led to the other; by some psychic necessity it provoked its counterpart. Having painted one side of the human situation, the artist had to paint the other. Through opposing forces like these, his vision unfolds. He is not unique in this, of course, but seldom can the polarity be seen, and confronted, so stalwartly.

Between such polarities, and many many more, Olli Lyytikäinen works his way through a highly personal Odyssey. One should perhaps not compare these two at

all, for Lyytikäinen—the Peter Pan of Finnish art—is, in his own way, almost totally un-Finnish: eccentric and versatile, with a variety of expression, that makes the elder artist seem a bit stuck-up in his role as a national mythmaker. When Olli was nineteen he moved around in the cafés of Helsinki, dressed in an English-style tweed suit, exhibiting peculiar neckties and other emblems of an original life-style, surprising his friends by turning out series of extraordinary drawings, images that seemed to us to come from another state of mind altogether. Strange portraits of imagined beings with real names: "Friedrich Nietzsche" seen as a schoolboy, taking a hesitant step; "Charlotte Corday" as an androgyne angel; "Jean Vigo" hypnotically staring into the spectator and his own mind, and many more.

On some archetypal levels Lyytikäinen seems to move on the same wavelength as Gallen-Kallela, but he is freer, more bizarre, more intense, "hot" and psychic—and thus maybe closer to another Nordic genius, Edvard Munch. The pictures are small in size but with a "high definition," revealing meanings beyond the dramatically gestural. For some fifteen years he has been drawing forth a continuous stream of personalities—as if from some huge unknown Image Bank in the Lower Manhattan of the Art World's mind. Where they really come from, and where they are going, and what Lord they are serving, really, it is hard to know, but everything is charged with meaning, energy.

Lyytikäinen could not repeat himself, and I doubt whether he could make a "bad" (uninteresting) image, even if he tried. Debasements and regressions just give access to more strange images. He does not hide behind squares or color fields—I don't think he could make an abstract picture. There is all too much anxiety and excitement, polarization and paranoia, hysteria and mystery, that need to be expressed. Idealization and destruction, awe and excitement mingle; every blessing seems to be connected with some cursing. The most longed for is intimately connected with the most feared. "Dogs bark in the basement while church bells ring in the tower." To handle all this demands unusual resources. The artistry is revealed in the way he manages to bind up and give meaningful life to agonizing energies.

J. O. Mallander

OLLI LYYTIKÄINEN
She-Wolf. 1974
Watercolor and pastel
11¹³⁄₁₆ × 15¾″ (30 × 40 cm.)
Collection Bo Alveryd, Kävlinge
Photo: Seppo Hilpo

OLLI LYYTIKÄINEN
Three Pyramids and the Sphinx. 1974
Watercolor and pastel
22⁷⁄₁₆ × 31½″ (57 × 80 cm.)
Collection Launo Laakkonen, Helsinki
Photo: Seppo Hilpo

OLLI LYYTIKÄINEN
Biking Hamlet. 1976
Watercolor and pastel
29½ × 20½″ (75 × 52 cm.)
Collection Stuart Wrede, Connecticut
Photo: Seppo Hilpo

OLLI LYYTIKÄINEN
Noah's Dream. 1978
Watercolor
7¹⁄₁₆ × 9¹⁄₁₆″ (18 × 23 cm.)
Collection Kirsti Lyytikäinen, Helsinki
Photo: Seppo Hilpo

OLLI LYYTIKÄINEN
Civet Cat. 1978
Watercolor
8¼ × 5⅞″ (21 × 15 cm.)
Collection Annmari Arhippainen, Helsinki
Photo: Seppo Hilpo

OLLI LYYTIKÄINEN
Counterpoint. 1977
Watercolor
8⅝ × 11¹³⁄₁₆″ (22 × 30 cm.)
Private Collection
Photo: Seppo Hilpo

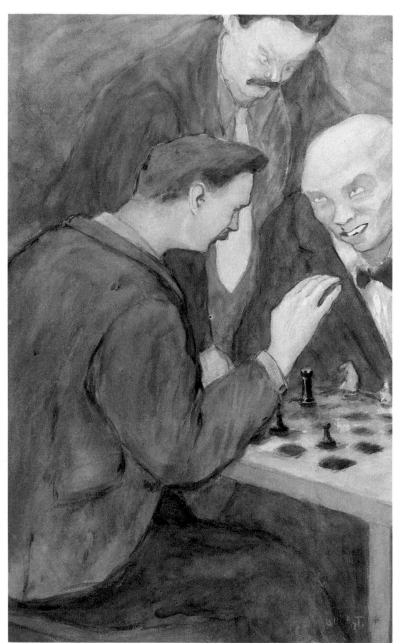

OLLI LYYTIKÄINEN
The Queen Threatened. 1976
Watercolor and pastel
28¾ × 17¹¹⁄₁₆″ (73 × 45 cm.)
Collection The Art Museum of
the Ateneum, Helsinki
Photo: Seppo Hilpo

OLLI LYYTIKÄINEN
Sven Duva in Hades. 1975
Watercolor and pastel
9⁷⁄₁₆ × 12⁹⁄₁₆″ (24 × 32 cm.)
Private Collection
Photo: Seppo Hilpo

OLLI LYYTIKÄINEN
Midsummer Night's Dream. 1977
Charcoal and wash
22¹⁄₁₆ × 29½″ (56 × 75 cm.)
Collection Sirkka Knuuttila, Helsinki
Photo: Seppo Hilpo

OLLI LYYTIKÄINEN
Grasshopper by a Rainbow. 1981
Watercolor and India ink
14¹³⁄₁₆ × 19¹¹⁄₁₆″ (36 × 50 cm.)
Private Collection
Photo: Seppo Hilpo

OLLI LYYTIKÄINEN
**Form and Content —
Content and Form.** 1977
Watercolor
18⅛ × 24″ (46 × 61 cm.)
Collection Sebastian Savander,
Helsinki
Photo: Seppo Hilpo

OLLI LYYTIKÄINEN
Being of Sound Mind. 1981
Watercolor and India ink
11¹³⁄₁₆ × 16⅛″ (30 × 41 cm.)
Collection Amos Anderson Art Museum, Helsinki
Photo: Seppo Hilpo

OLLI LYYTIKÄINEN
Farewell. 1978
Watercolor
8¼ × 5⅞″ (21 × 15 cm.)
Private Collection

OLLI LYYTIKÄINEN
4-colored Dream. 1978
Watercolor
8⅝ × 11¹³⁄₁₆″ (22 × 30 cm.)
Private Collection

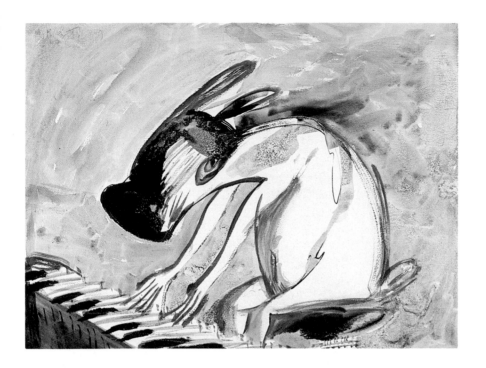

OLLI LYYTIKÄINEN
**Bunny Plays Bach on an
Electric Piano.** 1979
Watercolor, India ink and pastel
14³⁄₁₆ × 19¹¹⁄₁₆″ (36 × 50 cm.)
Private Collection
Photo: Seppo Hilpo

OLLI LYYTIKÄINEN
Ladies' Bicycle. 1977
Watercolor
23⅝ × 17¹¹⁄₁₆″ (60 × 45 cm.)
Collection Ulla and Stefan Sjöström,
Stockholm
Photo: Seppo Hilpo

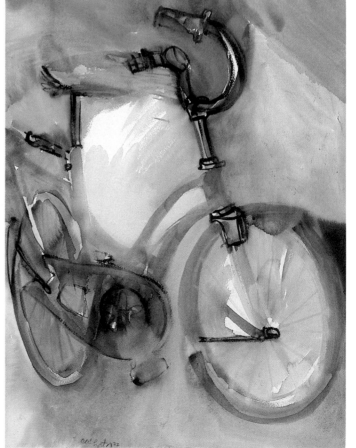

OLLI LYYTIKÄINEN
**"I was two and I killed the other—now
I am only one and I am so lonely."** 1981
Watercolor
11¹³⁄₁₆ × 16⅛″ (30 × 41 cm.)
Photo: Seppo Hilpo

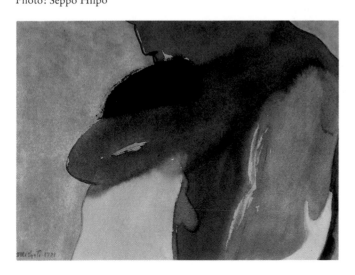

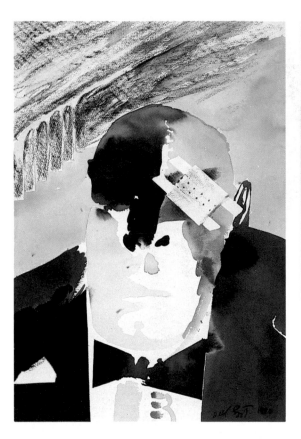

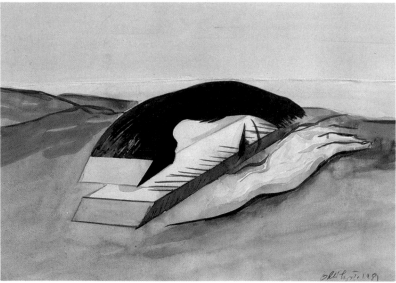

OLLI LYYTIKÄINEN
The Sphinx's Dream. 1981
Watercolor and India ink
14¹³⁄₁₆ × 19¹¹⁄₁₆″ (36 × 50 cm.)
Photo: Seppo Hilpo

OLLI LYYTIKÄINEN
Fire Chief. 1979
Watercolor and pastel
21⅝ × 14⁹⁄₁₆″ (55 × 37 cm.)
Photo: Seppo Hilpo

OLLI LYYTIKÄINEN
Red Star. 1976
Watercolor and pastel
16¹⁵⁄₁₆ × 23⅝″ (43 × 60 cm.)
Collection The Art Museum of
the Ateneum, Helsinki
Photo: Seppo Hilpo

OLLI LYYTIKÄINEN
Vernissage. 1977
Watercolor
6⁵⁄₁₆ × 5½″ (16 × 14 cm.)
Collection Amos Anderson
Art Museum, Helsinki
Photo: Seppo Hilpo

OLLI LYYTIKÄINEN
Overtaking . . . 1978
Watercolor
9⁷⁄₁₆ × 12⁹⁄₁₆″ (24 × 32 cm.)
Collection Helsingin Kaupungin Taidemuseo, Helsinki
Photo: Seppo Hilpo

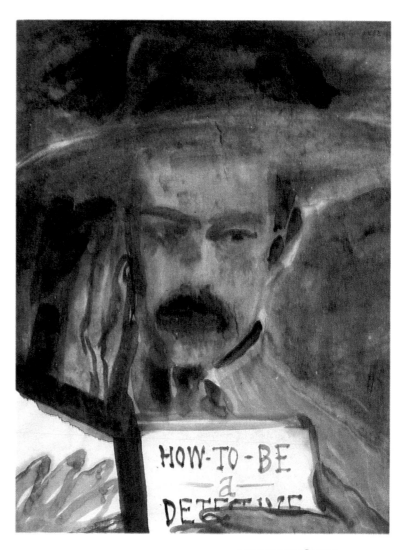

OLLI LYYTIKÄINEN
How to be a Detective. 1982
India ink
24³⁄₈ × 17¹¹⁄₁₆″ (62 × 45 cm.)
Photo: Seppo Hilpo

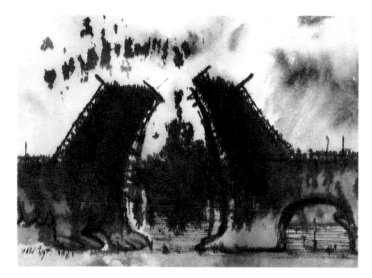

OLLI LYYTIÄINEN
Love in War. 1981
Watercolor and India ink
11¹³⁄₁₆ × 15¾″ (30 × 40 cm.)
Collection Svenska Handelsbanken, Stockholm
Photo: Seppo Hilpo

Bjørn Nørgaard

Born 1947 in Copenhagen. Lives in Copenhagen. Since 1964 member of The Experimental Art School (EKS-skolen), since 1972 member of the school's print shop Aps, and since 1976 member of group Arme og Ben (Arms and Legs). Has since 1969 collaborated on actions, performances, films, exhibitions etc. with Lene Adler Petersen.

Bjørn Nørgaard would like to thank the following persons and institutions for their generous help: Lene Adler Petersen, Finn Benthin, Herbert Krenchel, Erik Fischer, Flemming Jensen, Agri Contact Inc., The Collective Workshop in Nees, the Danmarks Nationalbank's Anniversary Foundation of 1968 and the New Carlsberg Foundation.

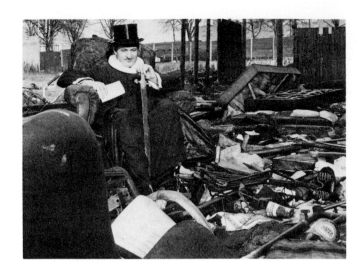

ONE MAN SHOWS (selection)
Once has one's bright moments, Daner Gallery, Copenhagen 1973
Take a cup of coffee, Gallery St. Petri, Lund, Sweden 1975
3 sandwiches and one beer, Daner Gallery, Copenhagen 1975
The fairy-hillock Maria's trench, Gallery 38, Copenhagen 1977
Cupola–Obelisk–Sarcophagus, Gallery Svend Hansen, Copenhagen 1978
Copyright HÆTSJJÖ, Department of Prints and Drawings, The Royal Fine Arts Museum, Copenhagen 1981
Kong, Gallery Flindt, Århus, Denmark 1981

GROUP SHOWS (selection)
The pupils' exhibition, State Academy of Art, Düsseldorf 1967
Young Danish Art Anniversary Exhibition, Louisiana Museum, Humlebæk, Denmark 1967
Tabernacle, Louisiana Museum, Humlebæk, Denmark 1970
Lene Adler Petersen, Per Kirkeby and Bjørn Nørgaard, Århus Kunstbygning, Århus, Denmark 1975
Arme und Beine, Art Museum, Lucerne 1976
The Death Leap, Charlottenborg, Copenhagen 1976
Paper (Arms and Legs), Århus Kunstbygning, Århus, Denmark 1977
10th Paris Biennale, Musée d'Art Moderne de la Ville de Paris 1977
Four Young Artists from the North, Henie-Onstad Art Center, Høvikodden; also shown at Kjarvalstadir, Reykjavik; Art Association, Copenhagen 1978
15th Middelheim Biennale, Middelheim Open Air Museum, Antwerp 1979
Danish Art 1969–1979 (Arms and Legs), anniversary exhibition of Tanegården, Gentofte, Denmark 1980
Venice Biennale 1980
The House as a Picture, Louisiana Museum, Humlebæk, Denmark 1981
13th International Symposium of Sculptors Forma Viva, Portoroz, Yugoslavia 1981

PERFORMANCES, HAPPENINGS, ACTIONS, FESTIVALS ETC.
Condition, Trækvogn 13 in cooperation with Joseph Beuys and Bengt af Klintberg. St. Kongensgade 101, Copenhagen 1966
Manresa, in cooperation with Henning Christiansen and Joseph Beuys, Galerie Schmela, Düsseldorf 1966
Man with plaster feet, Gallery 101, Copenhagen 1966
Concert in Nikolai Church, Henning Christiansen, Hans-Jørgen Nielsen and Johannes Stüttgen. (Eurasienstab hommage à Joseph Beuys) Copenhagen 1968
A Lecture on Architecture, performance with Lene Adler Petersen. School of Architecture, Copenhagen 1969
The Naked Female Christ, action with Lene Adler Petersen. The Exchange, Copenhagen 1969
Le Sacre du printemps, actions and films with Lene Adler Petersen. State Academy of Art, Düsseldorf 1969
The Horse Offering, action. Kirke-Hyllinge, Denmark 1970
A Lecture on Architecture II, performance with Lene Adler Petersen. School of Architecture, Copenhagen 1970
Mary Stuart (Schiller), performance with Lene Adler Petersen. Copenhagen and Paris 1977
The Oil-platform hommage à John Lennon, with Lene Adler Petersen and pupils of State Art Academy, Oslo 1980
Romeo and Juliet (Shakespeare), performance with Lene Adler Petersen and pupils of State Art Academy, Oslo 1980

REPRESENTED
Kobberstiksamlingen of Royal Fine Arts Museum, Copenhagen
Silkeborg Art Museum, Silkeborg, Denmark
Århus Art Museum, Århus, Denmark
Randers Art Museum, Randers, Denmark
Vejle Art Museum, Vejle, Denmark
North Jutland Arts Museum, Ålborg, Denmark
Henie-Onstad Art Center, Høvikodden, Norway
Moderna Museet, Stockholm
Art Museum, Lucerne
Kunstsammlungen der Veste Coburg, West Germany
Louisiana Museum, Humlebæk, Denmark

The Human Wall

Monumentality must emerge inexorably from within—that is true architecture. No petty-minded judgments of taste, but an architecture arising from needs and dreams, a form filled not by the academic grind but by genuine passion.

The Human Wall is all conceivable walls at once, its various figures are sculptures, pictures and people we meet and see. (The human figure in the history of art, man's interest in man throughout the ages.) And what, deep down, is more interesting than ourselves, the remarkable contradiction between our abnormal interest in ourselves and the happiness we achieve in total self-oblivion.

Architecture and sculpture, the wall and the people.

The Last Supper, with the thirteen men at table, and any gathering of people whatsoever, anywhere. (Earth) (Water) (Air) (Fire) and the smallest unit.

We produce classical art, because we use generally valid themes, the narrative and manifold and visionary image.

The structure of the work of art is a result of the work process. The work process is the result of the social conditions from which or in opposition to which the work of art emerges. A work of art is the dream, transformed into a material. When we produce monumental art today, it is in the desire to alter the conditions of art, and thus also the opportunities in our lives for dreaming.

We will take old images and use them again in a new way and make our own history in a word without history.

The only ultimate property things have is *that they are there.*

Art, in the sixties, acquired a new freedom; quality became character, style became structure, and the stuff of art was broadened to become anything, anywhere, and at any time.

Our task is not to make realistic demands, because we are not politicians.

Our task is to make unreasonable demands, because we are artists. But our unreasonable demands are the most realistic. "I'm always looking for an empty street," says Nam June Paik.

I think that art is always on the lookout for "empty streets," which is to say new areas in which to make art, new ways in which to make it.

The decisive thing for us when we work together is our attitude, a moral responsibility towards the visual image.

The concept of "style" does not exist for us. What others call "personal style" or "historical style" is re-placed with us by a concept of "raw material," a common title of ownership to both the historical and contemporary images, a free flow of information, ideas, conceptions, inventions and dreams between people, across all frontiers.

This presupposes that we should start thinking in a new way, organize ourselves in a new way, that all of us should be able to participate in the decision-making processes, that all of us should take responsibility for the decisions, and that all of us should be able to use our fantasy and creative capacity wherever we happen to live.

To live is to work. Who is the employer of art? Who is anyone's employer? Art defines its own working situation, its materials—in our society one confounds solidarity with institutions and organization with hierarchy. Artists identify themselves with common artistic visions and organize themselves into groups in connection with exhibitions, festivals, workshops, political parties and God knows what else in order to fulfill these common visions. Just as during the past decade we have seen people organize themselves freely in a common solidarity around new alternative colleges, residents-groups, environmental groups, new parties, working-environments, local newspapers, culture centers . . . it is a social model where everyone is creative. We do not make art according to the conditions of the present society, but in defiance of those conditions which our society presents us with.

Art has no other justification than its own presence. Its only raison d'être is that we are a group of people who insist that there ought to be a place for it, and its only standard of quality is its ability to destroy the established order and create images of an as yet non-existent world. Art must be impressive, social, beautiful, simple, classical, manifold, entertaining, amusing, funny, expressive, realistic, visionary, human, sublime, monumental, committed, ugly, direct

We dreamed, in the sixties, of abolishing the physical presence of art. Art was to be an idea that could enter any kind of context, and function there. And in the seventies we produced decorative art, and negotiated—with God and man alike. Today such optimism is difficult. The visual image is now returning to the canvas, where the conditions for dreams and conceptions are more favorable. Municipal authorities are more difficult to work with. The "New" painting, or whatever we like to call it, is an impatient but graceful gesture.

When I was small I went about a lot with my grandfather, who was almost blind, and when I had difficulty in explaining something I would take his great hand and draw with my little finger on his palm.

BJØRN NØRGAARD
Pouring of plaster. 1967

BJØRN NØRGAARD
Sculptural Demonstrations I. 1966
Action with the feet.
Galerie 101, Copenhagen and Galerie Schmela, Düsseldorf
Photo: Rainer Ruthenbeck

BJØRN NØRGAARD
**Lecture on Archi-
tecture.** 1969
With Lene Adler Petersen
Held in Copenhagen and in
Düsseldorf
Photo: Gregers Nielsen

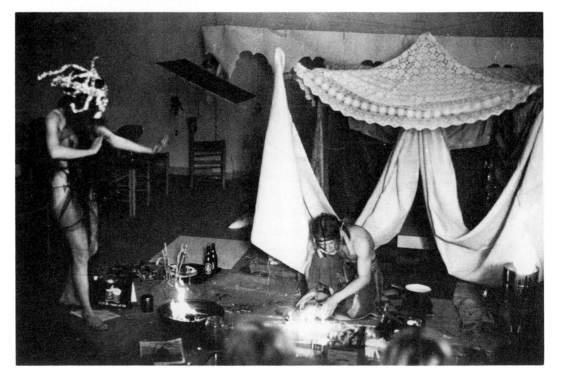

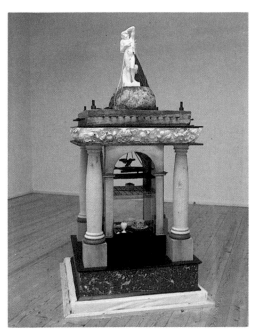

BJØRN NØRGAARD
Chr. III Mausoleum. 1975
Marble, wood, concrete, plaster, granite,
cloth, string, acrylic, brass and iron
86⅝″ (220 cm.) high
Collection Århus Art Museum, Denmark

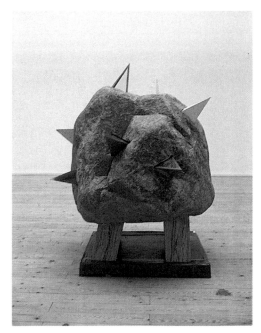

BJØRN NØRGAARD
Grave Hill III. 1975
Granite, marble, copper, glass, wood,
acrylic, cloth and plaster
64¹⁵⁄₁₆″ (165 cm.) high
Collection Silkeborg Art Museum, Denmark

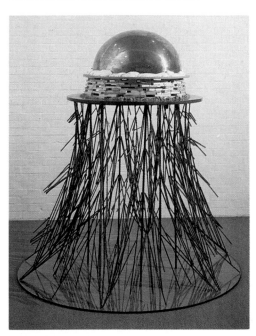

BJØRN NØRGAARD
Cupola. 1978
Copper, plaster, wood, concrete, marble,
iron and glass
66¹⁵⁄₁₆″ (170 cm.) high
Collection Århus Art Museum, Denmark

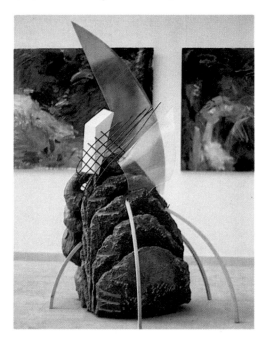

BJØRN NØRGAARD
The Spiral. 1980
Steel, acrylic, iron, plaster, granite,
bronze and wood, 86⅝″ (220 cm.) high
Collection Louisiana Museum, Humlebæk,
Denmark

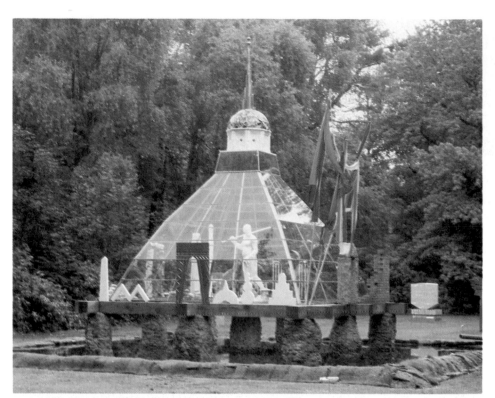

BJØRN NØRGAARD
The Dream Castle. 1979
295⁵⁄₁₆″ (750 cm.) high
Middelheim Biennale, Antwerp, Belgium
and North Jutland Arts Museum,
Ålborg, Denmark

BJØRN NØRGAARD
The Man on the Temple. 1980–81 ▶
Bronze, concrete, steel and glass
157½″ (400 cm.) high
Venice Biennale 1980
Collection Moderna Museet, Stockholm
Photo: Jan Almerén

BJØRN NØRGAARD
**The Portrait Busts of
Thorvaldsen.** 1976
Exhibition *Arms and Legs 1*
Art Museum, Lucerne

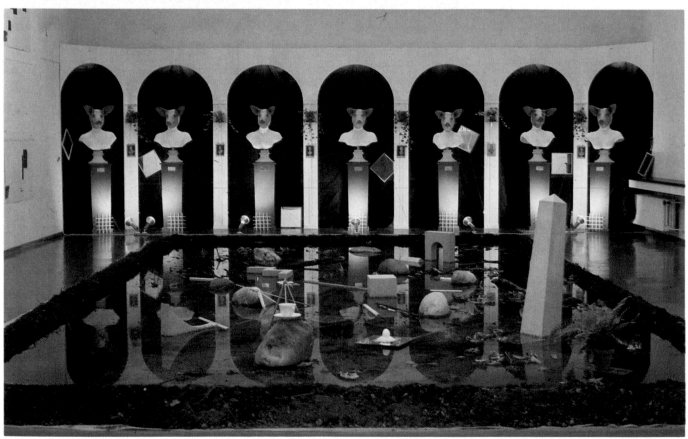

BJØRN NØRGAARD
Gate. 1978–81
Concrete, marble, bronze and wood
216¼″ (600 cm.) high
Collection Gladsaxe Main Library, Copenhagen
Photo: Gregers Nielsen

BJØRN NØRGAARD
Spiral. 1978–81
Corten steel
69⁵⁄₁₆″ (176 cm.) high
Collection Gladsaxe Main Library, Copenhagen
Photo: Gregers Nielsen

BJØRN NØRGAARD
Cornice Figure. 1978–81
Fiber-reinforced concrete
94¼″ (240 cm) high
Collection Gladsaxe Main Library, Copenhagen
Photo: Gregers Nielsen

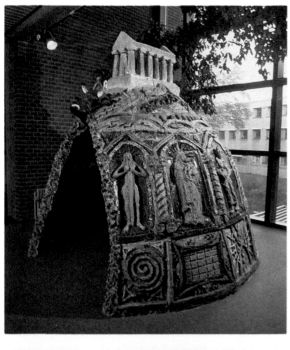
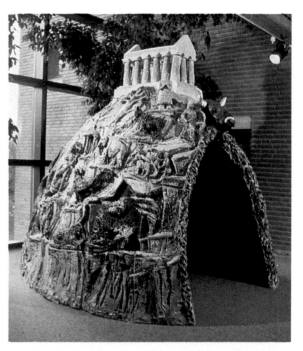

BJØRN NØRGAARD
Cave. 1978–81
Glazed ceramic
86⅝″ (220 cm.) high
Collection Gladsaxe Main Library, Copenhagen
Photo: Gregers Nielsen

BJØRN NØRGAARD
Tower. 1978—81 **Pyramid.** 1978—81
Wood, steel and copper Concrete, aluminium and glass
610⁵⁄₁₆ (1,550 cm.) high 275⁵⁄₈″ (700 cm.) high
Collection Gladsaxe Main Library, Copenhagen
Photo: Gregers Nielsen

BJØRN NØRGAARD
**Concrete Foundation with Painted
Pillars.** 1978—81
Collection Gladsaxe Main Library, Copenhagen
Photo: Gregers Nielsen

BJØRN NØRGAARD
Painted Concrete Pillars. 1978—81
98⅜″ (250 cm.) high
Collection Gladsaxe Main Library, Copenhagen
Photo: Gregers Nielsen

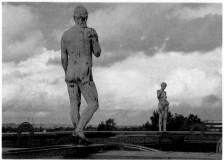

BJØRN NØRGAARD
Bronze Figures. 1978—81
Life size
Collection Gladsaxe Main Library, Copenhagen
Photo: Gregers Nielsen

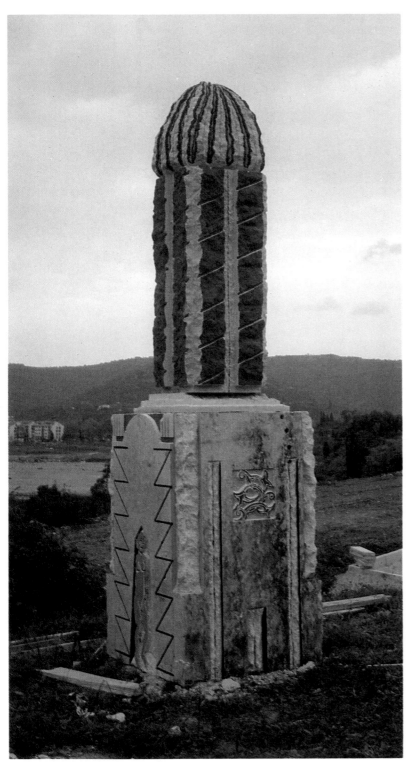

BJØRN NØRGAARD
Fountain. 1981
Glazed stoneware
55⅛″ (140 cm.) high

BJØRN NØRGAARD
The Temple of Change. 1981
Painted marble
177³⁄₁₆″ (450 cm.) high
Portoroz, Yugoslavia

BJØRN NØRGAARD
The Last Supper. 1981
Glazed stoneware
31½″ (80 cm.) high

Paul Osipow

Born 1939 in Kymi, Finland. Lives in Järvenpää.
Studies at The School of the Art Academy of Finland
1958–62, The Free Art School, Helsinki 1960 and at
University of Texas, Austin 1975. Since 1978 Professor
at The School of the Art Academy of Finland.

ONE MAN SHOWS (selection)
Gröna Paletten, Stockholm 1965
Museum of Central Finland, Jyväskylä, Finland 1966
Helsinki City Gallery, Helsinki 1969
Ässä Gallery, Helsinki 1973
Printmakers' Gallery, Helsinki 1974
Helsinki City Gallery, Helsinki 1975
Painters' Gallery, Helsinki 1977
Galleriet, Lund, Sweden 1979
Galerie Aronowitsch, Stockholm 1980
Gallery Sculptor, Helsinki 1981
Galerie Artek, Helsinki 1981
Galleriet, Lund, Sweden 1982

GROUP SHOWS (selection)
50th Anniversary of Independence of Finland, Hungary,
 Poland 1966–67
Scandinavian Art, Stockholm 1967
Kunst aus Finnland, Kunsthalle, Kiel, West Germany 1969
Constructivism, Helsinki 1973
4 Konstruktivisten aus Finnland, Wuppertal, West Germany
 1976

12 Artists, Helsinki 1977–78
Finnish Constructivism, University Art Museum, Austin,
 Texas 1979; also shown at Ringling Art Museum, Sarasota,
 Florida 1979 and De Cordova Museum, Lincoln, Mass.
 1980
Form and Structure, Vienna, Budapest, Madrid 1980
Konstruktivismus aus Finnland, Winterthur, Switzerland
 1981
First Sapporo Triennale, Sapporo, Japan 1981

REPRESENTED
Moderna Museet, Stockholm
Ateneum, Helsinki
Amos Anderson Art Museum, Helsinki
Sara Hildén Art Museum, Tampere, Finland
Turku Art Museum, Turku, Finland
Collection of the State of Finland
Maire Gullichsen Museum, Pori, Finland
Simo Kuntsi's Collection, Vasa, Finland
Helsinki City Collection
Kunsthalle, Rostock, East Germany
The National Arts Council, Sweden

By the means, and the effect, of color, you can
lend interest to the most commonplace things, and
make a masterpiece from a bowl, and some fruit.
But how is this to be achieved? You search, you
erase, you rub, you glaze, you repaint, and when
you've captured the "something" that pleases you
so much, the Picture is complete.

Jean-Baptiste Simeon Chardin

La peinture, c'est comme la merde; ça se sent, ça ne
s'explique pas.

Henri de Toulouse-Lautrec

In the twilight glow I see her
Blue eyes cryin' in the rain
When we kissed goodbye and parted
I knew we'd never meet again

Love is like a dyin' ember
And only memories remain
Through the ages I'll remember
Blue eyes cryin' in the rain

Someday when we meet up yonder
We'll stroll hand in hand again
In a land that knows no parting
Blue eyes cryin' in the rain

Fred Rose

STRUCTURE WITHOUT LIFE IS DEAD.
BUT LIFE WITHOUT STRUCTURE IS
UN-SEEN.

John Cage
"Lecture on nothing"

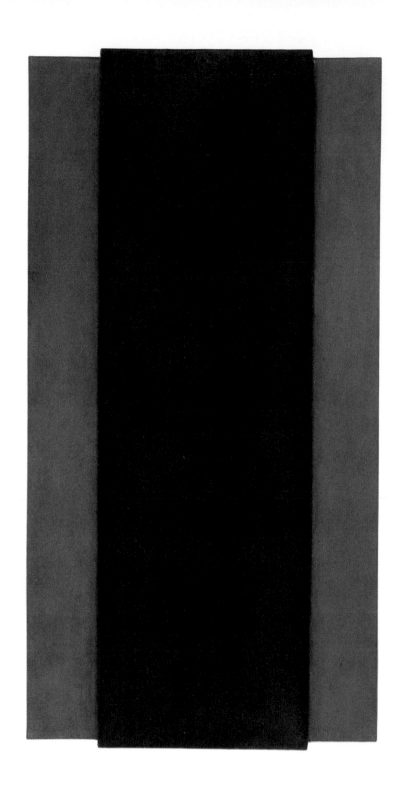

PAUL OSIPOW
Untitled. (Red-Hooker's Green). 1982
Acrylic on canvas mounted on board
59¹⁄₁₆ × 29½″ (150 × 75 cm.)
Photo: Seppo Hilpo

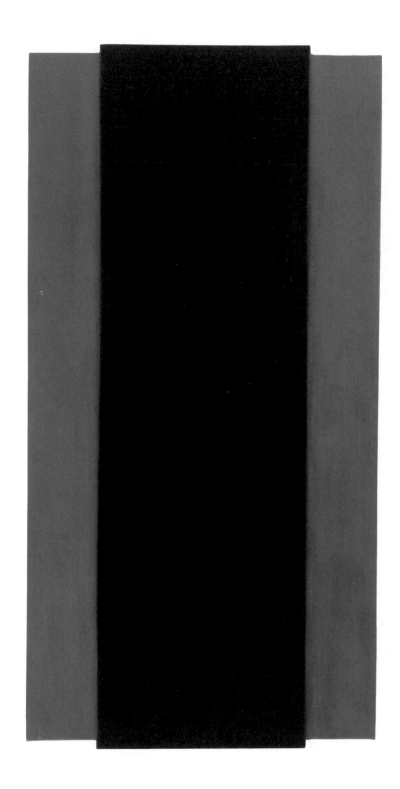

PAUL OSIPOW
Untitled. (Blue-Hooker's Green on Red). 1982
Acrylic on canvas mounted on board
59 1/16 × 29 1/2 (150 × 75 cm.)
Photo: Seppo Hilpo

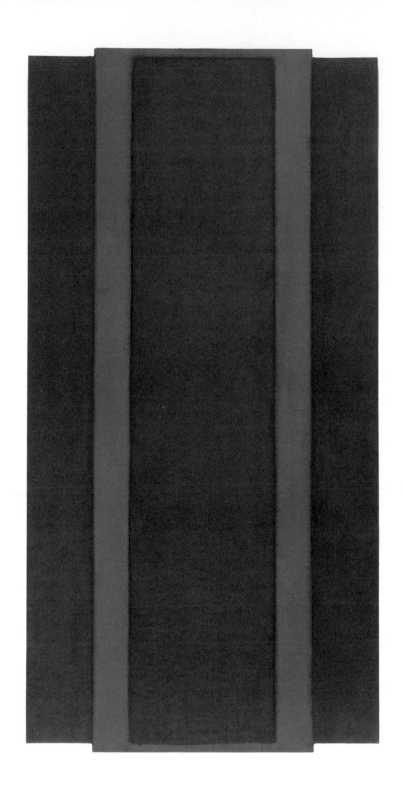

PAUL OSIPOW
Untitled. (Red−Green/Blue). 1982
Acrylic on canvas mounted on board
59¹⁄₁₆ × 29½″ (150 × 75 cm.)
Photo: Seppo Hilpo

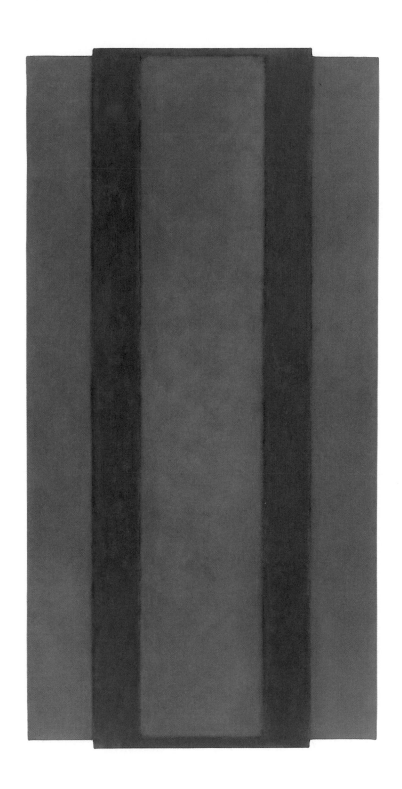

PAUL OSIPOW
Untitled. (Green–Blue). 1982
Acrylic on canvas mounted on board
59¹⁄₁₆ × 29½″ (150 × 75 cm.)
Photo: Seppo Hilpo

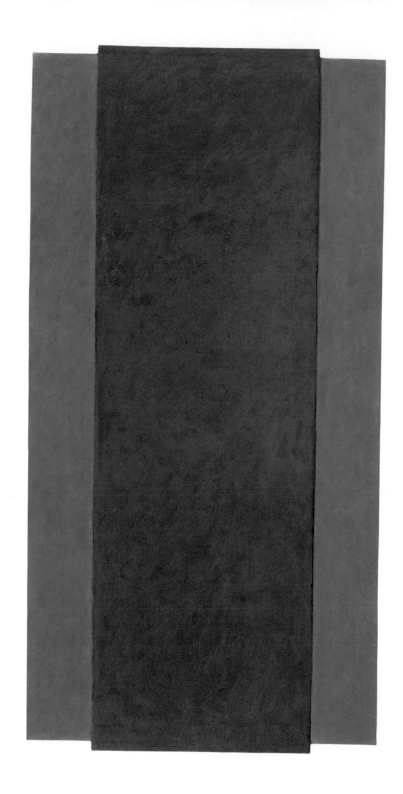

PAUL OSIPOW
Untitled. (Blue–Red on Black). 1982
Acrylic on canvas mounted on board
59¹⁄₁₆ × 29½″ (150 × 75 cm.)
Photo: Seppo Hilpo

120

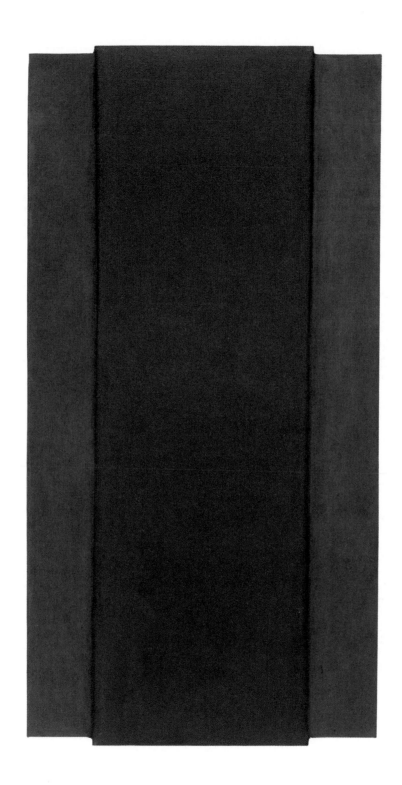

PAUL OSIPOW
Untitled. (Ochre/Gray—Red). 1982
Acrylic on canvas mounted on board
59¹⁄₁₆ × 29½″ (150 × 75 cm.)
Photo: Seppo Hilpo

Arvid Pettersen

Born 1943 in Bergen, Norway. Lives in Oslo.
Studies at Bergen College of Art and Crafts 1964−67.
Member of artists' group LYN (Flash) 1975−80. Guest
professor at Art Academy of Bergen and Art School of
Trondheim since 1977.

ONE MAN SHOWS (selection)
Gallery 1, Bergen 1970
Stavanger Art Gallery, Stavanger, Norway 1970
Trondheim Art Society, Trondheim, Norway 1971
Tønsberg Art Association, Tønsberg, Norway 1971
Bergen Art Association 1972
UKS, Oslo 1973
Larvik Art Association, Larvik, Norway 1974
Oslo Art Association, Oslo 1975
Gallery 1, Bergen 1975
Stavanger Art Gallery, Stavanger, Norway 1979
Gallery K, Oslo 1980
Bergen Art Association, Bergen 1980
Trondheim Art Association, Trondheim, Norway 1981

GROUP SHOWS (selection)
Bellevue−Bellevue, Oslo Art Association 1972
Galeria Nova, Barcelona 1972
Nordic Pavilion, Venice Biennale 1976

Eye to Eye, Liljevalchs Art Hall, Stockholm 1976
Art Landscape−Landscape Art, Henie-Onstad Art Center,
 Høvikodden, Norway 1978
The Lyn Group Show, Bergen Art Association 1979
The Lyn Group Show, Henie-Onstad Art Center, Høvikod-
den, Norway 1980
The Artists' House, Oslo 1981

PUBLIC COMMISSIONS
Bergen University 1977
Laxevaag Crafts School (in cooperation with Bård Breivik),
 Laxevaag, Norway 1978
Wall for the Social Ministry, Oslo 1982

REPRESENTED
Nasjonalgalleriet, Oslo
Bergen Picture Gallery
Stavanger Faste Gallery, Stavanger, Norway
Norwegian Arts Council, Oslo

Gangrene

In September 1980 I opened an exhibition at the Trondheim Art Society with twenty-eight paintings (acrylic, oils, tempera and offset) and nine transformed objects (a board from a rowing boat, rooftiles, demolition material from the conversion of my studio, a protective metal plate, and a doormat from the Art Gallery, which served for the following three weeks to wipe the dust and antiquated conceptions from people's eyes). All objects with a visual potential, and mounted in such a way as to comprise an esthetic whole without any formal modifications on my part. I also exhibited some forty pencil sketches and twenty acrylic sketches, mounted edge to edge in the fourth, and smallest, exhibition room.

The paintings were mainly simple still lifes and interiors of a fairly large format, and with painterly references to the entirely specific Nordic variant on late French Impressionism. Some of the paintings contained pseudo-primitive masks. Four hung free without stretchers, and were painted partly in a primitive, abstract style—as symbols and patterns on stretched hides. One was a combination of offset and oil painting, based on a photo of Jerry Lewis, hung-over in his touring aircraft. The drawings and sketches described details and situations from everyday life.

For me this exhibition, with its large range, and its juxtaposition of paintings, fragments, sketches and ready-mades, was a fairly tough confrontation with the tradition from which I had drawn visual nutrition, and I realized that I had somehow or another to revitalize my relationship towards it. Otherwise, I should have to stop making pictures.

It was like discovering that I was suffering from gangrene. I have taught periodically as a guest lecturer at the Trondheim Academy of Art, and I was asked by the teachers there to produce the occasional work in collaboration with the school. We agreed on three hours instruction in drawing, but with a view always to confronting the teaching regularly provided at the school. The principle, in other words, of tactical confusion.

As if in a carefully synchronized play of events, I arrived at the school at precisely the same moment as two young women students, who have as strong a relationship with Punk/Provo as I had to the "Nordic variant of late French Impressionism." They had punked themselves into the Cooperative Slaughterhouse in Trondheim, got by the Securitas guard (on the

pretext that they wanted to buy wool), and were returning to the Academy just as I arrived. They had with them two skeletons of goats, five flayed cowhides and seven sheep's heads. All these had been slaughtered that same morning. I was permitted to borrow the two goat's skeletons, and thus had a chance to apply the human whirlwind principle in a three-hour-long compressed lesson in drawing, on the basis of two bloody cadavers of goats. At the same time, the two students set out the five skins and seven chopped-off sheep's heads in various rhythmic patterns on grey paper out in the yard (c. 2 × 8 meters). A steaming séance was there enacted, flanked by wide-eyed first-year students and teachers, and not without a certain amount of blood-dripping ballistics. The flayed cowhides flew through the air, before delineating with a wet thud the soft forms that gravitation for the moment dictated. The sections cut in the sheep's skulls just behind the ears, the raw smell of slaughter, the trancelike motions of the two women, the confrontation with something as close to life as death, and the sensitivity of the organic material in relation to time—all this led me to experience the entire act in clear relationship to my own exhibition.

One of the sheep's heads described a broad, gliding z-movement, and came to rest on its chopped-off surface, turned heavenwards in a bloody calligraphic character. This was something of the most beautiful, most poetically charged experiences I have ever had.

Back in Oslo I began to ponder over what had happened in Trondheim. The encounter with my own exhibition, and the event that took place at the Academy.... I began to think about the heavily burdened tradition of painting, the eternally dictated form of the canvas and stretcher, and so on. An incessant tomfoolery with tricks to create illusions, and technically fixated processes.... The value of what I was doing in relation to the economic dictates of the market, and my communication of thoughts, ideas and visual possibilities.... I had been referring to visual traditions, and had seen myself in a natural extrapolation of these.

I had to break this dependence, otherwise I would find myself in an utterly locked relationship to the job of producing pictures. Until that time I had painted objects: now I had to try to transfer my pictures to real objects. The concrete canvas, the surface or the thing, without the illusory

pictorial world, but with the colors as a cover, indicating a visual play and a painterly tradition.

Gradually, I began to envisage solutions in which the pictures were cut from their frames, and divided up into different geometric forms. Might they then emerge as "objects" with an entirely different "charge" than they had had before?

We set about it in the middle of the exhibition period. Some of the students from the Academy came along, both to assist and to take photographs throughout the process. Fourteen paintings were cut out and pinned back into place. Some of them with solutions defined in advance, while others were more or less "caught in the act." Some pictures were indifferent after they had been cut, while others were charged with a new energy that delighted me. The reactions of the public and my colleagues also suggested that the specific field in which painting operates had really been broadened. The knife cut into a tradition that people experienced both mentally and physically, and for a while the temperature was superbly high.

I had sawn off the branch on which I had been sitting, and I experienced the sense of freedom that arises when you are in free flight, and uncertain where you are going to land: you simply enjoy the flight. This was the first link in a long chain of possibilities.

When I used a knife, I could just as well have resorted to a hammer, an axe, a plane, electronics or gunpowder. The possibilities of combining conventional painting with any other materials and techniques whatsoever I felt to be legion. I had acknowledged my debt to tradition, and I knew that I had to run the entire gauntlet in order to pay it back. Otherwise I should only be able in the future to *function* traditionally, and that is far from being part of the duties of a visual artist.

A journey to Tassiliij n'Ajjer in the heart of the Sahara desert at the turn of the year 1981/82, to see the historic rock paintings (between 4,000 and 6,000 years old), confirmed anew the sense of seeing oneself as part of an infinite process of visual communication.

Anachronistically enough, my most recent pictures are more firmly tied to the tradition than previously: the difference is simply that I am now working with open doors.

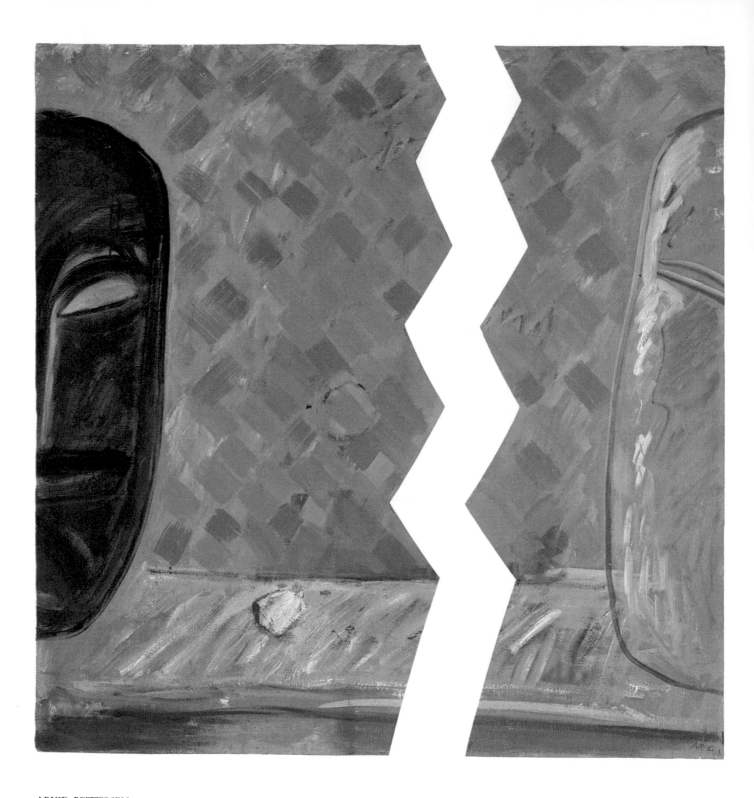

ARVID PETTERSEN
Mantelpiece. 1981
Oil on canvas
49⅝ × 43⁵⁄₁₆″ (126 × 110 cm.)
Photo: Tore Rönneland

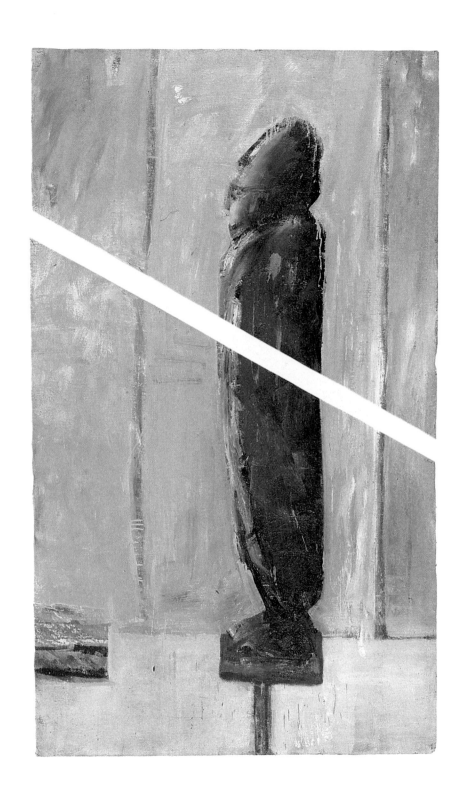

ARVID PETTERSEN
Ancestor. 1981
Oil on canvas
66^{15}⁄$_{16}$ × 39^3⁄$_8$″ (170 × 100 cm.)
Photo: Tore Rönneland

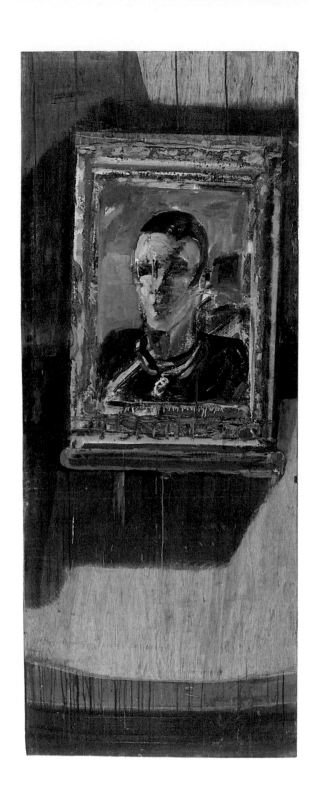

ARVID PETTERSEN
Interior with Painting. 1982
Tempera and oil on board
79¼ × 29¹⁵⁄₁₆″ (200 × 76 cm.)
Det Faste Galleri, Trondheim
Photo: Tore Rönneland

128

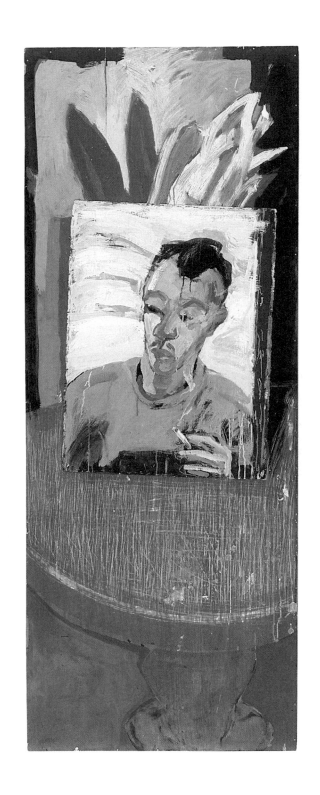

ARVID PETTERSEN
Portrait. 1982
Tempera on board and paper
77⁹⁄₁₆ × 29¹⁵⁄₁₆″ (197 × 76 cm.)
Courtesy Galleri K., Oslo
Photo: Tore Rönneland

ARVID PETTERSEN
Book and Knife. 1981
Oil on canvas
69^{11}/$_{16}$ × 85^{13}/$_{16}$″ (177 × 218 cm.)
Photo: Tore Rönneland

ARVID PETTERSEN
Masks. 1981
Acrylic on paper and canvas
59¹/₁₆ × 35¹/₁₆″ (150 × 89 cm.)
Collection Den norske Creditbank, Oslo
Photo: O. Væring

Checklist of the exhibition

All works not otherwise noted are lent by the artist

BÅRD BREIVIK

1. **Untitled I.** 1982
 Hazel wood
 83 × 14 × 14″ (210 × 36 × 36 cm.)

2. **Untitled II.** 1982
 Steel (forged)
 83 × 14 × 14″ (210 × 36 × 36 cm.)

3. **Untitled III.** 1982
 Steel (⁴⁄₁₆″ – 8 mm.)
 83 × 14 × 9½″ (210 × 36 × 24 cm.)

4. **Untitled IV.** 1982
 Laminated wood and zinc
 83 × 14 × 9½″ (210 × 36 × 24 cm.)

5. **Untitled V.** 1982
 Mixed media
 83 × 14 × 8¼″ (210 × 36 × 21 cm.)

6. **Untitled VI.** 1982
 Mixed media
 83 × 14 × 8¼″ (210 × 36 × 21 cm.)

7. **Untitled VII.** 1982
 a) Black rubber
 83 × 14 × 7¹⁄₁₆″ (210 × 36 × 18 cm.)
 b) Vulcalan rubber
 83 × 14 × 7¹⁄₁₆″ (210 × 36 × 18 cm.)

8. **Untitled VIII.** 1982
 Lead
 83 × 14 × 7⅛″ (210 × 36 × 20 cm.)

9. **Untitled IX.** 1982
 Mixed media
 83 × 14 × 8¼″ (210 × 36 × 21 cm.)

LARS ENGLUND

10. **Relative I.** 1982
 Graphitefibre
 approximately 393 × 236 × 236″
 (1,000 × 600 × 600 cm.)

11. **Relative II.** 1982
 Kevlar
 approximately 120 × 120 × 120″
 (300 × 300 × 300 cm.)

HREINN FRIDFINNSSON

12. **Seven Times.** 1978–79
 Photograph
 31½ × 47¼″ (80 × 120 cm.)
 State-Owned Art Collections
 Department, The Netherlands

13. **A While.** 1978–79
 Three panels, photograph, watercolor
 and wood-carving
 23⅝ × 47¼″ (60 × 120 cm.)

14. **Couplet.** 1978–79
 Four panels, photograph, watercolor
 and wood-carving
 39⅜ × 47¼″ (100 × 120 cm.)

15. **The Hour.** 1980
 One piece on wall, wood-carving
 49¼ × 74¹³⁄₁₆″ (125 × 190 cm.)
 One piece on floor, marble, wood,
 gold and silver
 53³⁄₁₆ × 74¹³⁄₁₆″ (135 × 190 cm.)
 Collection the City of Amsterdam

16. **Territory.** 1982
 Photograph and chalk on paper
 59¹⁄₁₆ × 59¹⁄₁₆″ (150 × 150 cm.)
 Collection the City of Amsterdam

17. **From Time To Time.** 1978–79
 Six panels, photograph and text
 27⁹⁄₁₆ × 63″ (70 × 160 cm.)

18. **Serenata.** 1982
 Photograph, glass and wood
 63 × 102⅜″ (160 × 260 cm.)

SIGURDUR GUDMUNDSSON

19. **Rendez-vous.** 1976
 Photograph and text on cardboard
 28⁹⁄₁₆ × 35⅞″ (72.5 × 91 cm.)
 Collection Moderna Museet, Stockholm

20. **Molecule.** 1979
 Color photograph with text
 51³⁄₁₆ × 59¹⁄₁₆″ (130 × 150 cm.)
 Rijksmuseum Kröller-Müller, Otterlo,
 The Netherlands

21. **The Katanes Beast.** 1981
Drawing
47¼ × 74⅜″ (120 × 189 cm.)

22. **Untitled Black Sculpture.** 1981
Tar on wood and glass
137¹³⁄₁₆ × 27⁹⁄₁₆ × 27⁹⁄₁₆″
(350 × 70 × 70 cm.)

23. **Mathematics.** 1979
Color photograph with text
45¼ × 50⅜″ (115 × 128 cm.)
Rijksmuseum Kröller-Müller, Otterlo,
The Netherlands

24. **Historiana.** 1981
Photograph with text
40⁹⁄₁₆ × 45¹¹⁄₁₆″ (103 × 116 cm.)

25. **The Great Poem.** 1981
Concrete, swans and steel
137¹³⁄₁₆ × 137¹³⁄₁₆ × 59¹⁄₁₆″
(350 × 350 × 150 cm.)
Stedelijk Museum, Amsterdam

26. **Mountain.** 1980–82
Photograph with text
50⅜ × 53¹⁵⁄₁₆″ (128 × 137 cm.)

PER KIRKEBY

27. **Plate II.** 1981
Oil on canvas
37⅜ × 45¹¹⁄₁₆″ (95 × 116 cm.)
Courtesy Galerie Michael Werner,
Cologne

28. **Untitled (Cave).** 1981
Oil on canvas
45¹¹⁄₁₆ × 37⅜″ (116 × 95 cm.)
Courtesy Galerie Michael Werner,
Cologne

29. **Untitled.** 1981
Oil on canvas
37⅜ × 45¹¹⁄₁₆″ (95 × 116 cm.)
Courtesy Galerie Michael Werner,
Cologne

30. **Untitled (Cave).** 1981
Oil on canvas
37⅜ × 45¹¹⁄₁₆″ (95 × 116 cm.)
Courtesy Galerie Hans Neuendorf,
Hamburg

31. **Plate III.** 1981
Oil on canvas
37⅜ × 45¹¹⁄₁₆″ (95 × 116 cm.)
Courtesy Galerie Michael Werner
Cologne

32. **Untitled.** 1981
Oil on canvas
45¹¹⁄₁₆ × 37⅜″ (116 × 95 cm.)
Courtesy Galerie Hans Neuendorf,
Hamburg

33. **Plate VII.** 1981
Oil on canvas
45¹¹⁄₁₆ × 37⅜″ (116 × 95 cm.)
Courtesy Galerie Fred Jahn, Munich

34. **Untitled** (Horse Head). 1981
Oil on canvas
45¹¹⁄₁₆ × 37⅜″ (116 × 95 cm.)
Courtesy Galerie Michael Werner,
Cologne

OLLE KÅKS

35. **Uprooted.** 1979
Oil on canvas mounted on panel
variable size, approximately
78¾ × 393¾″ (200 × 1,000 cm.)

36. **Coléopter.** 1980
Oil on canvas mounted on panel
103⅛ × 236¼″ (262 × 616 cm.)
Musée National d'Art Moderne,
Centre Georges Pompidou, Paris

37. **Market Garden.** 1982
Oil on canvas
110¼ × 233⅞″ (280 × 594 cm.)

OLLI LYYTIKÄINEN

38. **She-Wolf.** 1974
Watercolor and pastel
11¹³⁄₁₆ × 15¾″ (30 × 40 cm.)
Collection Bo Alveryd, Kävlinge

39. **Three Pyramids and the Sphinx.**
1974
Watercolor and pastel
22⁷⁄₁₆ × 31½″ (57 × 80 cm.)
Collection Launo Laakkonen, Helsinki

40. **Biking Hamlet.** 1976
Watercolor and pastel
29½ × 20½″ (75 × 52 cm.)
Collection Stuart Wrede, Connecticut

41. **Noah's Dream.** 1978
Watercolor
7¹⁄₁₆ × 9¹⁄₁₆″ (18 × 23 cm.)
Collection Kirsti Lyytikäinen, Helsinki

42. **Counterpoint.** 1977
Watercolor
8⅝ × 11¹³⁄₁₆″ (22 × 30 cm.)
Private Collection

43. **Sven Duva in Hades.** 1975
Watercolor and pastel
9⁷⁄₁₆ × 12⁹⁄₁₆″ (24 × 32 cm.)
Private Collection

44. **The Queen Threatened.** 1976
Watercolor and pastel
28¾ × 17¹¹⁄₁₆″ (73 × 45 cm.)
Collection Ateneum Art Museum,
Helsinki

45. **Midsummer Night's Dream.** 1977
Charcoal and wash
22¹⁄₁₆ × 29½″ (56 × 75 cm.)
Collection Sirkka Knuuttila, Helsinki

46. **Grasshopper by a Rainbow.** 1981
Watercolor and India ink
14¹³⁄₁₆ × 19¹¹⁄₁₆″ (36 × 50 cm.)
Private Collection

47. **Form and Content – Content
and Form.** 1977
Watercolor
18⅛ × 24″ (46 × 61 cm.)
Collection Sebastian Savander,
Helsinki

48. **Being of Sound Mind.** 1981
Watercolor and India ink
11¹³⁄₁₆ × 16⅛″ (30 × 41 cm.)
Collection Amos Anderson
Art Museum, Helsinki

49. **Farewell.** 1978
Watercolor
8¼ × 5⅞″ (21 × 15 cm.)
Private Collection

50. **4-colored Dream.** 1978
Watercolor
8⅝ × 11¹³⁄₁₆″ (22 × 30 cm.)
Private Collection

51. **Bunny Plays Bach on an Electric
Piano.** 1979
Watercolor, India ink and pastel
14³⁄₁₆ × 19¹¹⁄₁₆″ (36 × 50 cm.)
Private Collection

52. **"I was two and I killed the other–
now I am only one and I am so
lonely."** 1981
Watercolor
11¹³⁄₁₆ × 16⅛″ (30 × 41 cm.)

53. **Ladies' Bicycle.** 1977
Watercolor
23⅝ × 17¹¹⁄₁₆″ (60 × 45 cm.)
Collection Ulla and Stefan Sjöström,
Stockholm

54. **Fire Chief.** 1979
Watercolor and pastel
21⅝ × 14⁹⁄₁₆″ (55 × 37 cm.)

55. **The Sphinx's Dream.** 1981
Watercolor and India ink
14¹³⁄₁₆ × 19¹¹⁄₁₆″ (36 × 50 cm.)

56. **Red Star.** 1976
Watercolor and pastel
16¹⁵⁄₁₆ × 23⅝″ (43 × 60 cm.)
Collection Ateneum Art Museum,
Helsinki

57. **Vernissage.** 1977
Watercolor
6⁵⁄₁₆ × 5½″ (16 × 14 cm.)
Collection Amos Anderson
Art Museum, Helsinki

58. **Overtaking...** 1978
Watercolor
9⁷⁄₁₆ × 12⁹⁄₁₆″ (24 × 32 cm.)
Collection Helsingin Kaupungin
Taidemuseo, Helsinki

59. **How to be a Detective.** 1982
India ink
24⅜ × 17¹¹⁄₁₆″ (62 × 45 cm.)

60. **Love in War.** 1981
Watercolor and India ink
11¹³⁄₁₆ × 15¾″ (30 × 40 cm.)
Collection Svenska Handelsbanken,
Stockholm

BJØRN NØRGAARD

61. **The Human Wall.** 1982
Ceramic, concrete, wood, stone,
and bronze
approximately 45 × 15 × 90′
(15 × 5 × 30 meters)

PAUL OSIPOW

62. **Untitled. (Red-Hooker's Green).**
1982
Acrylic on canvas mounted on board
59¹⁄₁₆ × 29½″ (150 × 75 cm.)

63. **Untitled. (Blue-Hooker's Green on Red).** 1982
Acrylic on canvas mounted on board
59$\frac{1}{16}$ × 29$\frac{1}{2}$″ (150 × 75 cm.)

64. **Untitled. (Red–Green/Blue).** 1982
Acrylic on canvas mounted on board
59$\frac{1}{16}$ × 29$\frac{1}{2}$″ (150 × 75 cm.)

65. **Untitled. (Green–Blue).** 1982
Acrylic on canvas mounted on board
59$\frac{1}{16}$ × 29$\frac{1}{2}$″ (150 × 75 cm.)

66. **Untitled. (Blue–Red on Black).** 1982
Acrylic on canvas mounted on board
59$\frac{1}{16}$ × 29$\frac{1}{2}$″ (150 × 75 cm.)

67. **Untitled. Ochre/Gray–Red).** 1982
Acrylic on canvas mounted on board
59$\frac{1}{16}$ × 29$\frac{1}{2}$″ (150 × 75 cm.)

ARVID PETTERSEN

68. **Mantelpiece.** 1981
Oil on canvas
49$\frac{5}{8}$ × 43$\frac{5}{16}$″ (126 × 110 cm.)

69. **Ancestor.** 1981
Oil on canvas
66$\frac{15}{16}$ × 39$\frac{3}{8}$″ (170 × 100 cm.)

70. **Interior with Painting.** 1982
Tempera and oil on board
79$\frac{1}{4}$ × 29$\frac{15}{16}$″ (200 × 76 cm.)
Det Faste Galleri, Trondheim

71. **Portrait.** 1982
Tempera on board and paper
77$\frac{9}{16}$ × 29$\frac{15}{16}$″ (197 × 76 cm.)
Courtesy Galleri K., Oslo

72. **Book and Knife.** 1981
Oil on canvas
69$\frac{11}{16}$ × 85$\frac{13}{16}$″ (177 × 218 cm.)

73. **Masks.** 1981
Acrylic on paper and canvas
59$\frac{1}{16}$ × 35$\frac{1}{16}$″ (150 × 89 cm.)
Collection Den norske Creditbank, Oslo